# Old Faithful

# Old Faithful

## DOGS OF A CERTAIN AGE

PETE THORNE

HARPER
DESIGN
An Imprint of HarperCollinsPublishers

HarperCollins books may be purchased for educational, business,
or sales promotional use. For information please email the
Special Markets Department at SPsales@harpercollins.com.

Published in 2015 by
Harper Design
*An Imprint of* HarperCollins*Publishers*
195 Broadway
New York, NY 10007
Tel: (212) 207-7000
Fax: (855) 746-6023
harperdesign@harpercollins.com
www.hc.com

Distributed throughout the world by
HarperCollins *Publishers*
195 Broadway
New York, NY 10007

ISBN 978-0-06-241345-1
Library of Congress Control Number: 2015941484

Printed in China

First Printing, 2015

To my grammother, Doris Elwyn Young, for her 102nd birthday

&

To all the old and faithful dogs who have passed before my camera,
and for those who have passed away.

# Introduction

In 2013, I photographed my grandmother's hundredth birthday party.

It was after that birthday that I found myself wanting to explore the idea of aging. However, I had always photographed human subjects and was looking for a challenge (a change?). I have a huge soft spot for older dogs, and I began really noticing how much character older dogs showed in their faces. I had never photographed animals before so I knew I had found my subject.

I found myself seeking out elderly dogs and their owners. I didn't really know much about senior dogs, having moved away from home before my dog's golden years. I knew that older dogs are often passed over in favor of younger, cuter puppies in shelters and elsewhere. Yet I knew that they were the ones that more often than not needed more attention, not less.

I was naive going into it. I was initially interested in photographing old dogs as caricatures of old guys and gals. My perception of the project quickly evolved as the owners' emotional responses made me aware of the deep connection that owners have with their pets, especially ones they have had for a good portion of their lives.

And it wasn't until I created a Facebook page and began posting the images alongside their testimonials that I saw the incredible degree to which the images and subject matter were resonating with people. People from across the globe began posting pictures of their own dogs and sharing their own pet's stories.

I noticed how distinct older dogs' faces are compared to more youthful ones: lumps and bumps, gray hair, chipped and missing teeth. Some dogs had lost their eyesight (some were missing their eyes altogether)—evidence of both a struggle with old age and of a life well lived.

And I began to realize that it wasn't that these older dogs needed more attention—it was that they commanded more attention. In my grandmother's first hundred years, she saw more things than most of us could even imagine. More joys, more triumphs, more sadness, more everything.

In *Old Faithful*, the dogs' lives are written all over their faces. Lifetimes of digging, barking, licking, loving, and being loved. These dogs have comforted you, frustrated you, peed on you, and been your friend through it all. From thunderstorms to bath time. From housebreaking to heartworms.

Today, people from all over the world send me messages of gratitude for sharing the stories of these old dogs and for increasing awareness of the plight of abandoned and neglected animals. The next stage in the evolution of the project is to take it on the road. By expanding the project outside of Toronto and across North America, I can increase the project's audience, share more old dogs' stories, and perhaps help us to reassess society's dismissal of elderly subject matter in favor of youthfulness.

If there is one message that has resonated with everyone involved with this project, it's that despite everything we're told, faces, like companionship, just get better with age.

PETE THORNE

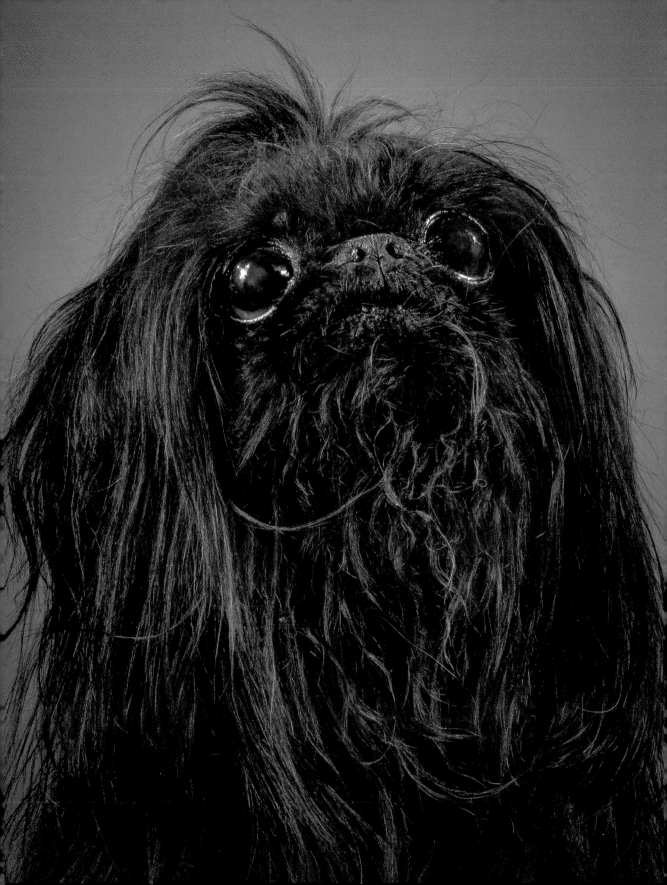

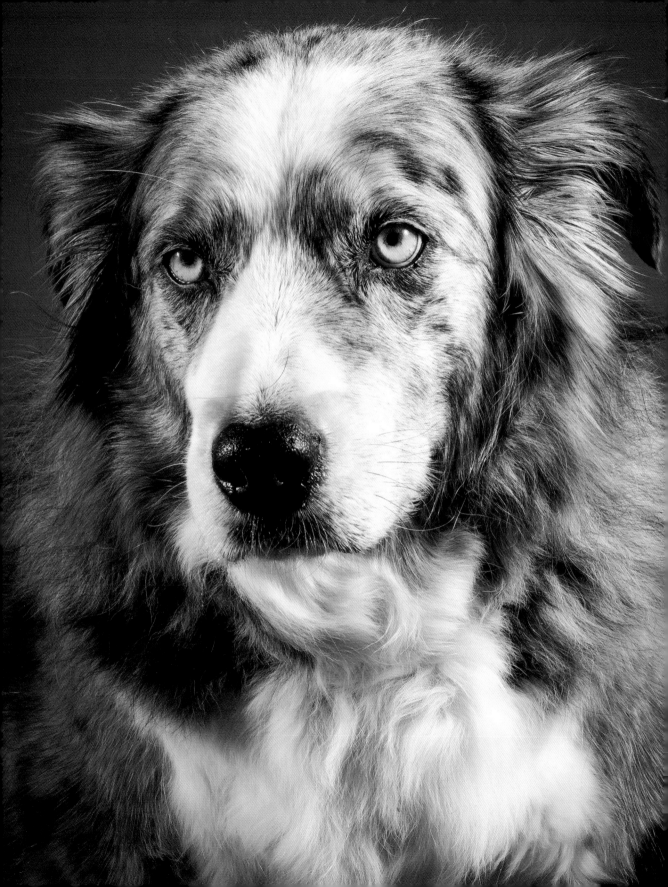

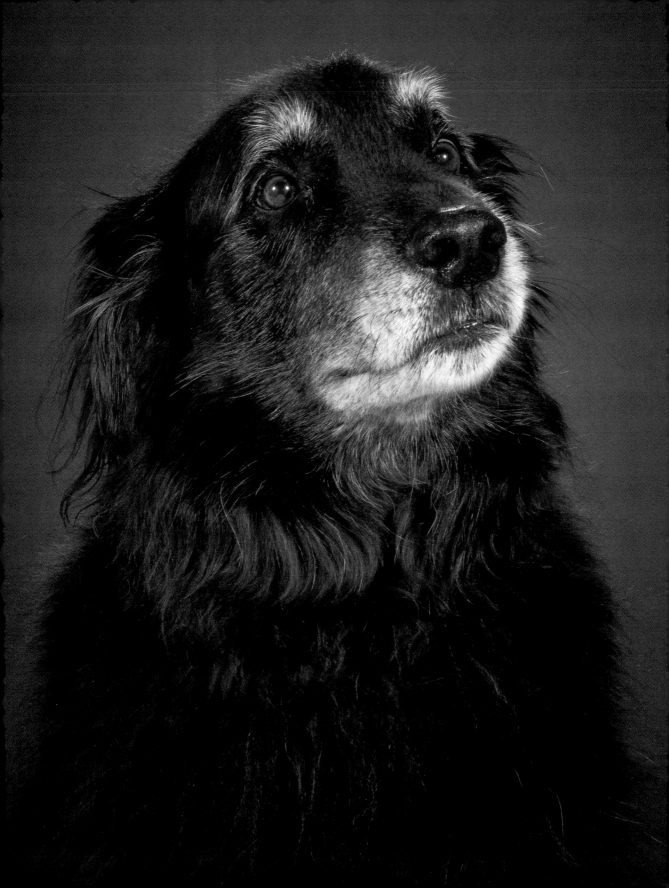

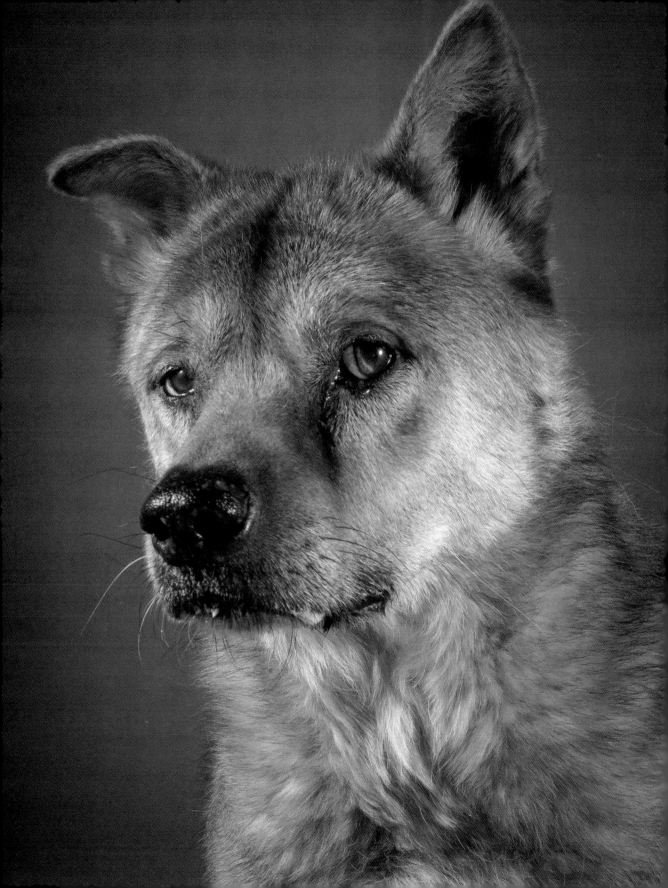

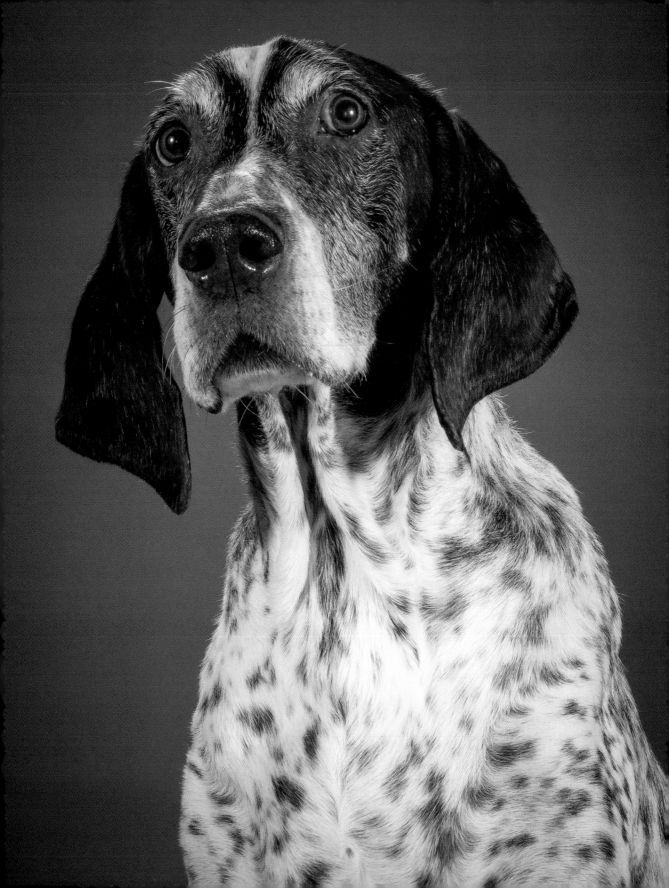

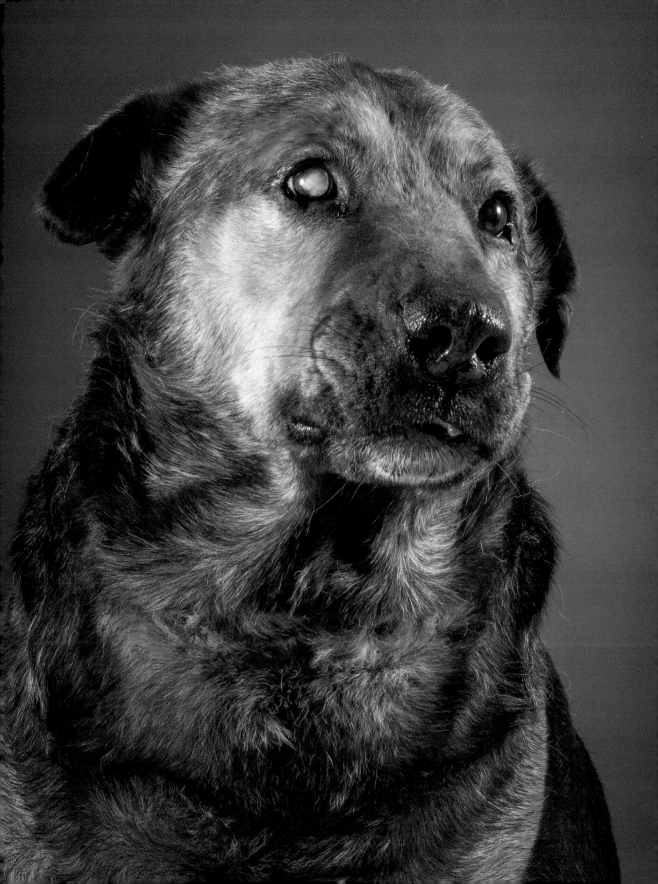

# Zoe

SHIH TZU, 12½

While Zoe is frequently mistaken for an Ewok, she is indeed a twelve-and-a-half-year-old purebred shih tzu. She might be little, but she makes up for that in personality.

Over the years, Zoe has been my shadow, following me all over the house, in the garden, and up and down the stairs, and accompanying me on short jaunts around the city and long trips across Canadian provinces. She loves life in the country, and when she was younger, she'd chase bunnies all summer long at our cottage. These days she's slowed down due to heart problems and blindness in one eye. It seems I am now her shadow, as I keep an eye on things she can no longer see. Despite these conditions, Zoe still does a twirl for her breakfast and supper and runs around like a puppy when I come home at the end of the day.

I have been blessed to be her lifelong companion. She has taught me how to love life and be present in the moment. When she's playing, that is all she's consumed with. When she's eating, she thinks of nothing else, except eating her own food and then the cats'. She loves prime rib bones, her stuffed bear, chasing paper balls, and running in open fields. After all these years, her puppy dreams bring a smile to my face every time.

My little cuddle bug has been with me through the good and difficult times, and I am grateful to be there for her in the very same way. Zoe's had her difficulties lately, but she keeps getting back up and proving me wrong. She can be stubborn like that.

MEGRET YABSLEY

# Maggie-Mae, aka Bubba Girl

CATAHOULA–BORDER COLLIE MIX, 11½

My Maggie is now eleven and a half years old. It's only the last couple of years that I've called her Bubba Girl. Bubba, an endearing nickname in the South, a big hunk of love.

I've seen her age over the last couple of years. It's sometimes hard for her to get up after she's been lying down for long periods. Her walker bought a ramp last year to help her get into the SUV because Maggie was having trouble jumping in and out on her own. There are times she chooses to stay downstairs and sleep because it's hard for her to get up the stairs. She looks tired, and has slowed down. She's become ornery.

I know Maggie's time will come. I don't think I will ever be ready for that. She's been there for me in ways I can't even express. She's shown me such simple pleasures and has taught me so much. After all this time, I realize that it really has been Maggie that's been taking me for the walk . . . the best walk anyone can have.

JACKIE POZENEL

# Chopper

MIX, 11

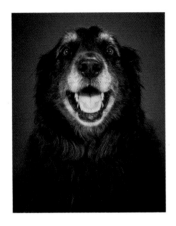

We adopted a tiny black ball of fur from a local pet shelter. As a puppy, Chopper was playful but easygoing. He grew and grew and grew. Now at one hundred and thirty pounds, he may look intimidating, but he is a gentle giant. Chopper is great with kids as well as dogs of all sizes. He has always welcomed the many dogs we have fostered in our home. Even though some have shown aggression toward Chopper, he has never returned it. His quiet, tranquil disposition seems to be calming, and helps them to transition into content and confident dogs. Chopper has matured into a very distinguished-looking fellow with his white muzzle and eyebrows. Always a gentleman, he is an extremely loving part of our family. We are truly fortunate to have such an amazing dog in our lives.

BONNIE LESLIE

# Buster

KOREAN JINDO, 13

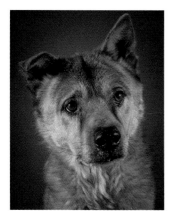

At the shelter, Buster had a sign on his pen that read: CAUTION: SHY DOG. It wasn't promising, but the volunteer said we should try him anyway. We took him out in the yard. Right away he jumped up in my lap. He has never done this again—I think he had watched other dogs at the shelter and figured out what he needed to do to get out. It worked.

For the first six months we had him, he seemed to only tolerate living with us. He didn't seem to actually like us for months. But he eventually decided we were his people. Buster is unlike any dog I've ever had. He's like a cat in a dog suit. Unlike our lab mix, he has no interest in pleasing us. But he does love us on his terms. Living with him has been like having an endless series of negotiations. I love watching the wheels in his head turn as he addresses a new challenge. I miss his youthful energy, but I don't miss his willingness to take on all challengers.

We think he's about thirteen now. The last year or so, he has started to show his age. He used to be very strong and would need hours of exercise every day. Now he seems to spend most of his time sleeping. And in the last few years he has gone deaf. We're beginning to have those tough conversations about what to do as the end draws near. It's hard to know that we may only have a short time left with him. Twelve years went by so fast.

BESS HAMILTON

# Crosby

GERMAN SHORTHAIRED POINTER, 14

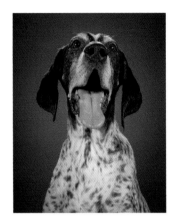

Crosby, a fourteen-year-old German shorthaired pointer, entered our lives and our hearts in 2012 when he was already twelve years old. He became homeless after being involved in a vehicle accident where he was uninjured but his owner passed away. He was housed at a boarding kennel for a long while before we discovered that he was in need of a home.

CKC records show that Crosby was born on August 1, 2000. Crosby has had a few owners during his life and hasn't always received the best care. When the boarding kennel took him in, he was 30 pounds overweight with very overgrown toenails. The kennel owners got the weight off and gave him a new lease on life.

Crosby is enjoying his retirement home. His favorite toy is a tiny plush Siberian tiger. He likes to chew on rawhide and tartar busters and loves to eat anything. When he begs, his eyes water and his whole body shakes.

Crosby refuses to swim and play fetch and he hates to go outside in the cold, snow, or rain for any reason. We actually have to gently push him out the door. Crosby is an affectionate fellow. He loves to be petted, and have his ears rubbed and hugged. If he is feeling especially loved, he will gently hold my arm or hand in his mouth, his teeth press ever so lightly into my skin. He loves his retirement home and we are enjoying all of the joy and love he has to offer.

TANYA WOHLSCLAGEL

# Al Poochino

MIX, 14

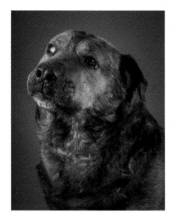

Big Al decided he was coming home with me during a trip to a remote community to feed some stray dogs in May 2014. We tried to find his owner to ask if he was allowed to just up and move to the Big City only to learn he didn't have an owner. The community had fed him during the fourteen years that he had hung around, and in his later years they built him a doghouse to protect him from the elements. His head, face, and body are full of scars, all with stories of their own. Some are from humans, some came from fighting for food, and some came from fighting for broads (his words). A true survivor, Al was not disparaging about his opponents, saying only, "You shoulda seen the other guy." Once in the care of a rescue organization, he went to a vet for his first vaccines, blood tests, and checkup. It was discovered that he is totally blind in his right eye, his teeth are worn down to stubs, and he tested positive for heartworm. As the treatment of heartworm involves injecting poison into the back, I was concerned his age would preclude treatment, but Al Poochino, in true survivor fashion, did survive and thrive. He started to play a little, run a little, and demand a lot of attention. He likes to lie on the coffee table in the evenings, surveying all that is now his, enjoying his retirement from a life of being a stray, and demanding to be brushed as much as possible.

KAREN SMITH

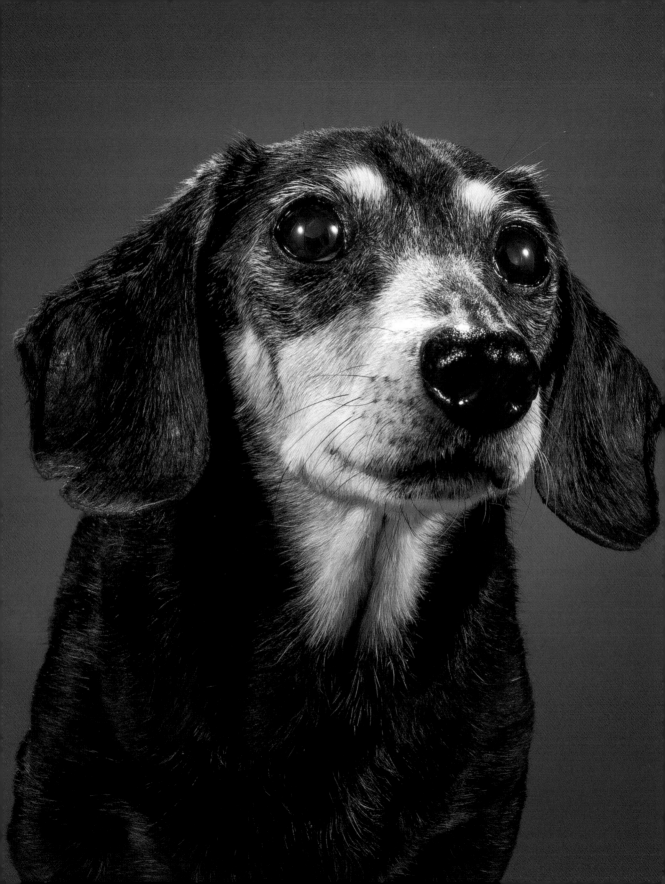

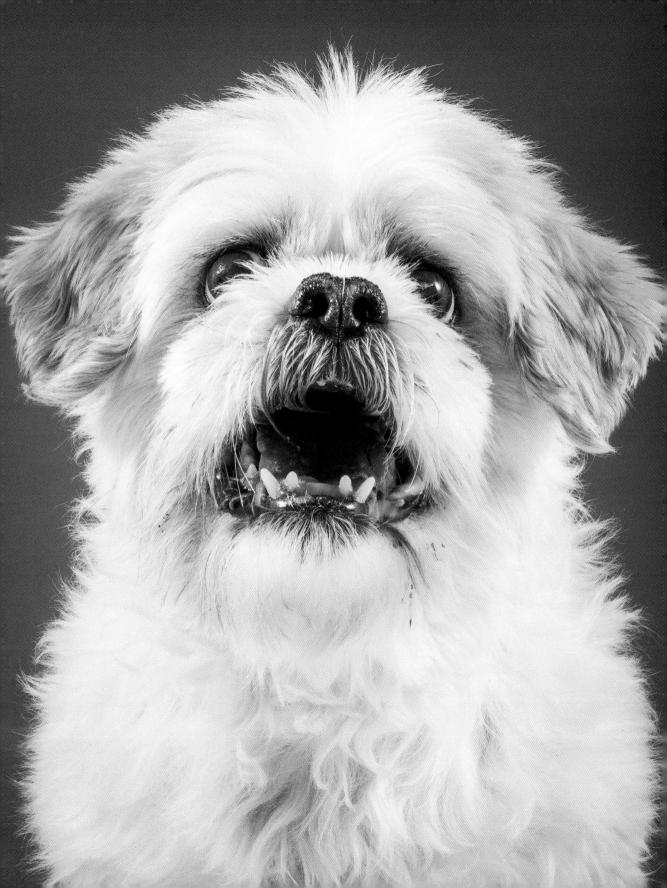

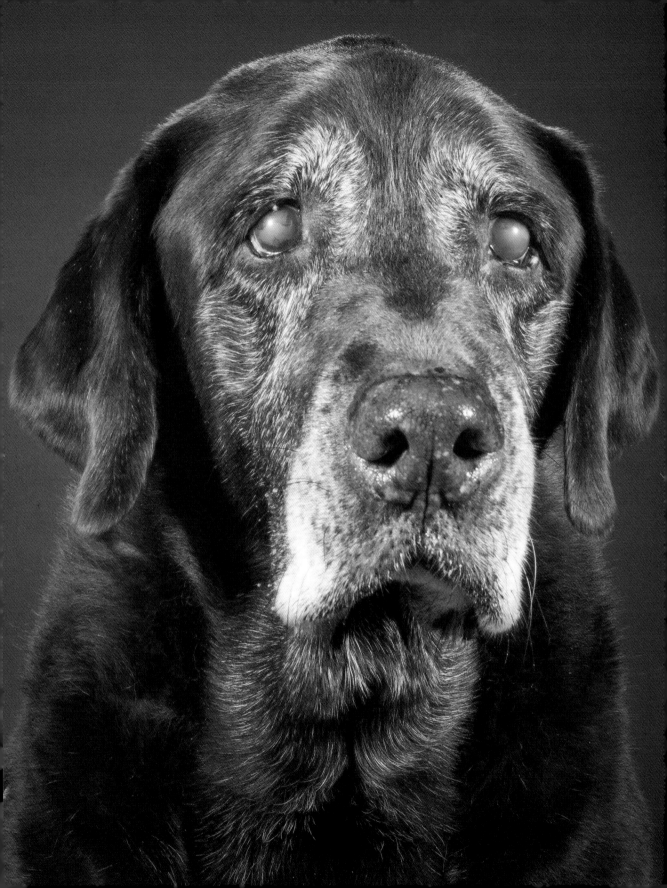

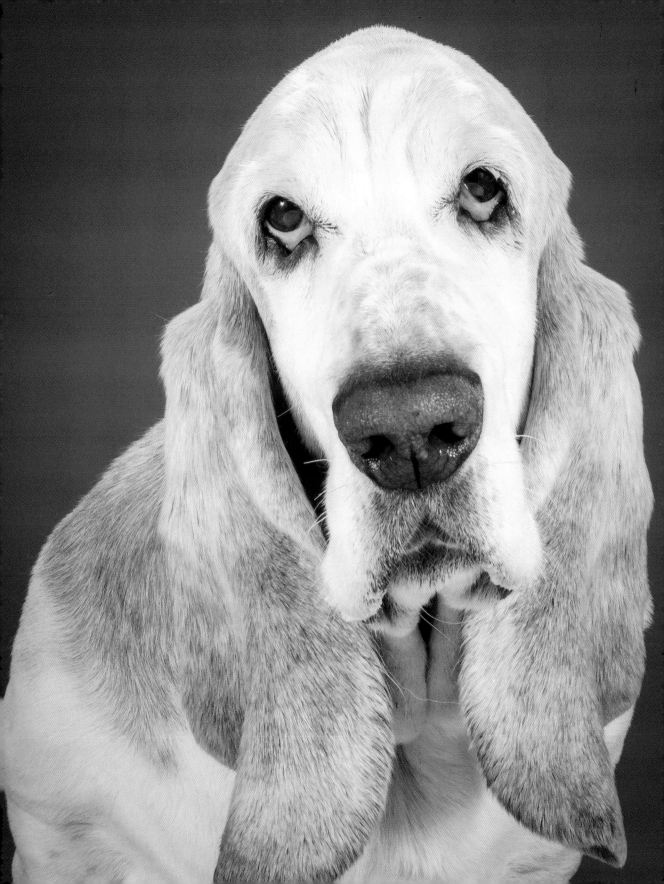

# Buddy

DACHSHUND, 18

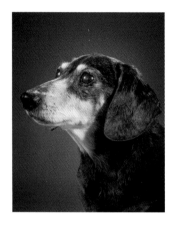

Buddy's last breaths were of the sea and the mountains of Vancouver. He left quietly and gently in the wee hours on August 25, 2014. His marvelous, massive spirit sailed off into the universe and joined the dusts of time with ease and reverence. Buddy gave the world eighteen years. It was time for him to go; his decision, not ours.

He may have been tiny but he was mighty, in soul and in spirit. We will never forget his loving, big googly eyes, his commanding bark, his sweet smell, his truest and purest love, and his little skip when he walked, his crooked elbows, the little notch in his left ear, and all his special idiosyncrasies.

It didn't matter who crossed his path, a smile was found. If an odd character messed with him and he had no time for that, an overly large threatening bark would follow. He rebuffed packs of wild dogs that would spring upon us, with fierce reproach and toothy shows, and strike fear into the pack, telling me that we were safe.

Buddy lived long, traveled lots, and made thousands of friends. He may not be with us physically but he will forever live on in our hearts. He belongs to the ages now, and his legacy, Buddy Belts, will ensure that a piece of him lives on forever. Hold his love close and remember to love up one another and treasure life's moments together.

JOHNNY AND ROXANNE PETTIPAS

# Joey

LHASA APSO, 12

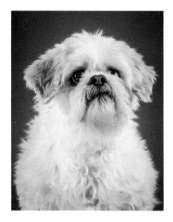

Joey is a senior Lhasa apso. We are his third home. Home number one neglected him to the brink of death. The woman who adopted him from that situation did a lot of work with him, but when we got him . . . there was still a lot to be done.

His nickname is Captain Bitey Dog, as he has bitten hard enough to draw blood.

My father had just passed away and my son was devastated, his grandfather meant the world to him. I wanted a dog to distract my boy, and Joey looked like a bundle of sweet fluff. It wasn't until we got him home that we realized his Tasmanian devil tendencies.

We knew that he just lacked confidence and was afraid of the world. Besides, he had bonded with my son and had given him something to take care of, so we consulted a trainer.

I awoke one morning to the following note on the kitchen whiteboard: "Joey is loose in the house. He bit me. Ignore him." Nothing like having a biting dog roaming the house during the night.

Truth be told, in the years that we have had him, he has mellowed considerably . . . and we have learned to read him better. He has a ton of personality and really just wants to be loved.

FAYE TARDIFF

# Miles

CHOCOLATE LAB, 12

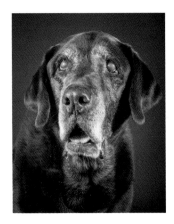

After regaining my balance and brushing the dusty prints from my shirt, I knew. Of all the sausage-shaped pups scurrying around the pen, he was the one. I first noticed him when he emerged from his mother's side, turned toward me, and dashed across the wood chips. Without hesitation, he threw himself into my chest, scraping and climbing his way toward my face. While his siblings huddled cautiously near their mother, he declared, "Pick me! Pick me!"

Over the next twelve years, Miles and I have become inseparable. He has accompanied me everywhere—to construction sites, office cubicles, campgrounds, hotels, motels, even dinner parties. If he couldn't come, I often found a reason not to go. We have climbed mountains, swam in rivers and lakes, slept in tents. His calm, quiet demeanor has endeared him even to those who tend to avoid our canine friends. I have often wondered if people visited our home just to spend time with him.

Miles began to lose his sight several years ago, so he no longer scampers around much anymore. He finds his peace now in simply being close, in maintaining that inseparable bond we first discovered twelve years ago. We have changed together, it seems. I have learned from him to appreciate the magic of being still, of being close, and of feeling safe with those you love. We enjoy our time together immensely now, maybe even more so than when we were younger and less appreciative of things that weren't bright and shiny. Now I play armchair philosopher and he a 120-pound lap dog. Often I'll pause from a book and find myself rubbing his ears, in that special spot that only we know. When he sighs, I know what he means.

KEVIN ROESSGER AND REBECCA OHMEN

# Buster

BASSET HOUND, 10½

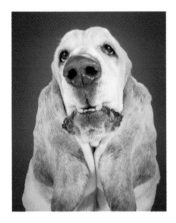

Whether he's on the big screen, doing some TV work, entertaining the crowds during obedience competitions, or just hanging out in front of the fireplace at home, Buster's gentle demeanor and silly expressions charm everyone he meets.

As the story goes, Buster definitely picked his owner, Trina. When Buster was just a pup and it came time for Trina to meet this sweet boy, he sauntered with intent straight over to Trina in a way only basset hounds are apt to do, hoisted himself up on her lap and proclaimed she was his. They have been constant companions ever since.

You can see Buster in movies such as: *New in Town*, *Beethoven Christmas Adventure*, and most recently *Heaven Is for Real*. They aren't big parts but Trina always thinks Buster steals the show.

When he's not "on the set" Buster is an accomplished show dog and also dabbles in competitive obedience and rally obedience. When he's having fun in the ring, everyone knows it because he loves to howl through the whole course. When he's not howling . . . that's when the trouble starts. Buster has been known to hightail it out of the ring to meet a certain favorite lady friend, or to head straight for the judges' desk, and, more specifically, the judges' bags, to see if he can find any wayward treats or snacks.

There's something really special about this boy. He certainly means the world to Trina and his younger basset brother—Baxter—and Buster's "poppa" Matt. Buster's not one for big showy signs of affection, but when he does cuddle up or want to sneak in a little kiss, this sweet smoosh really knows how to lay on the charm.

TRINA GALLOP

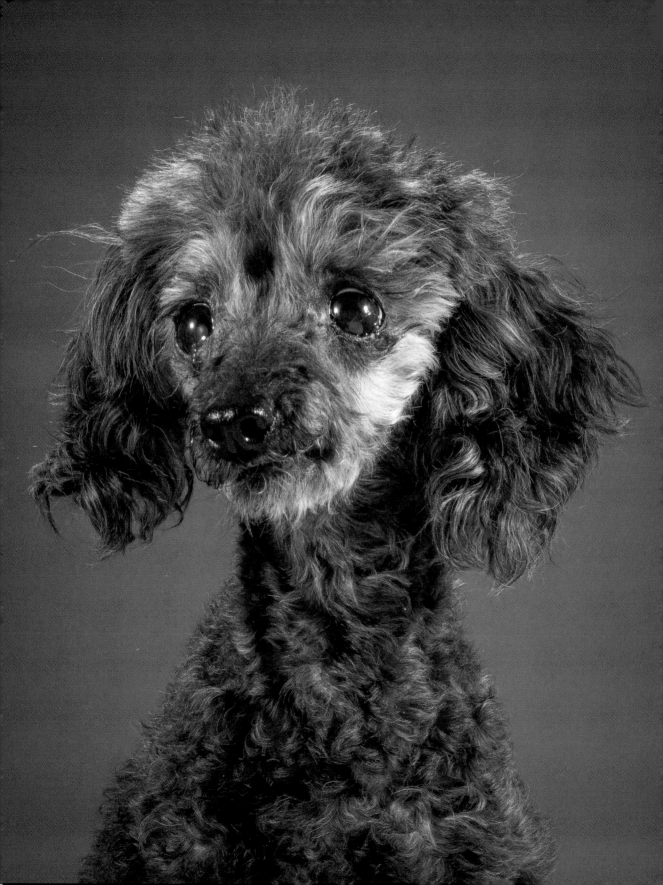

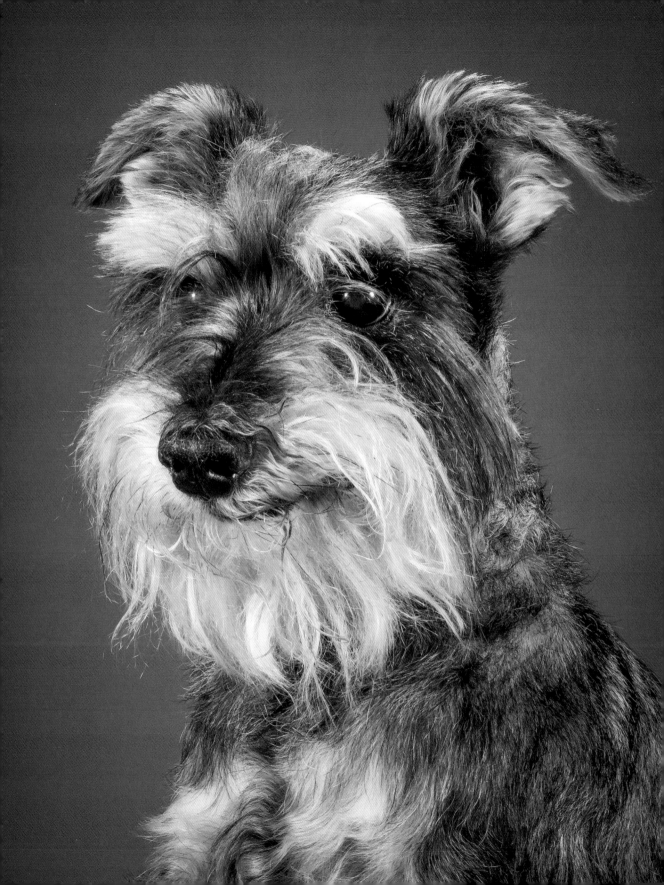

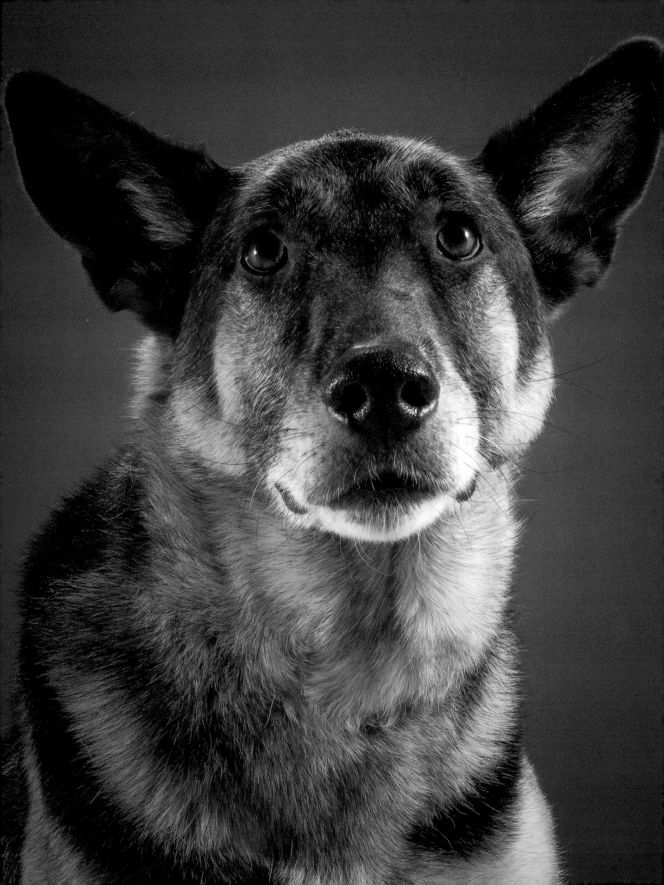

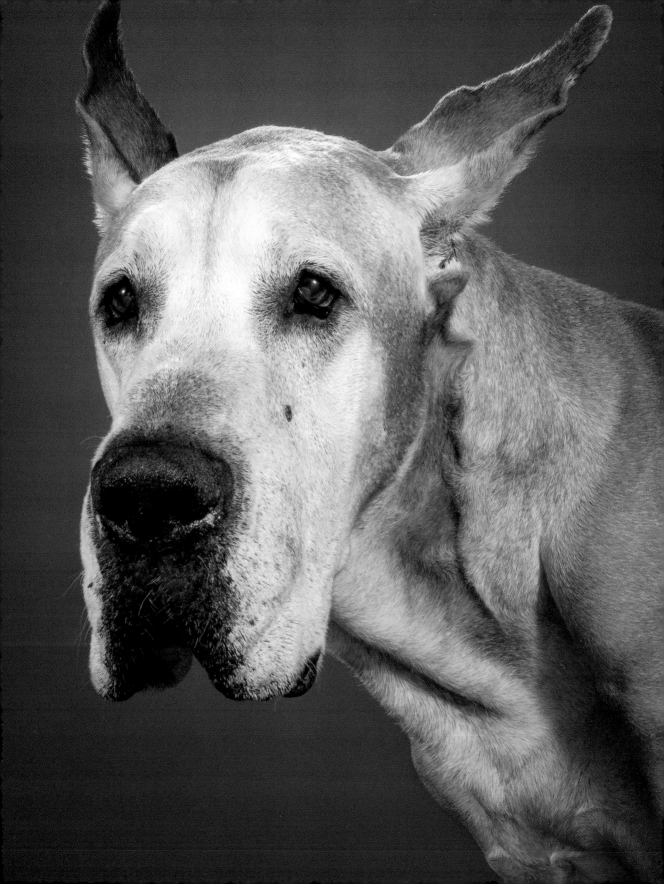

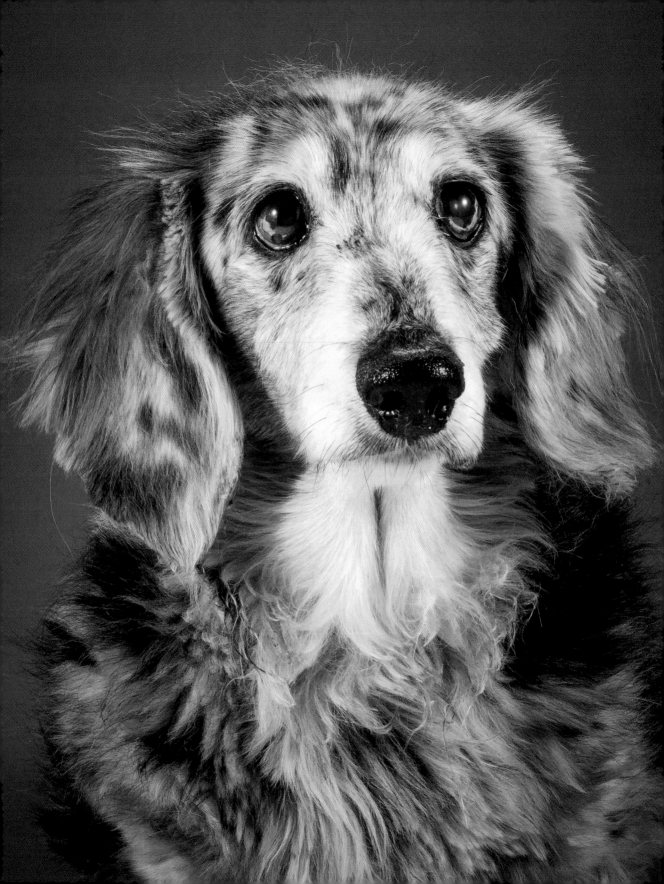

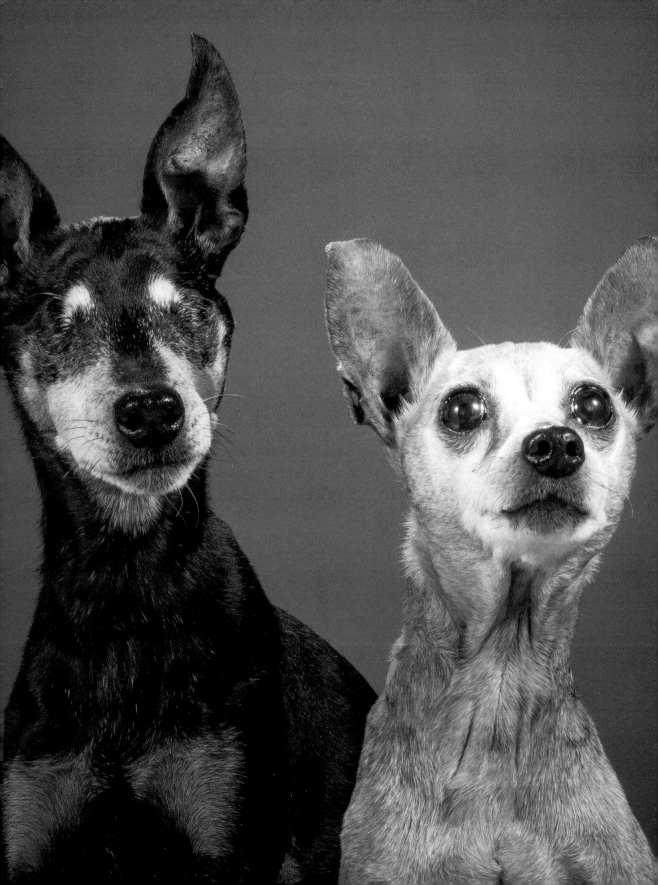

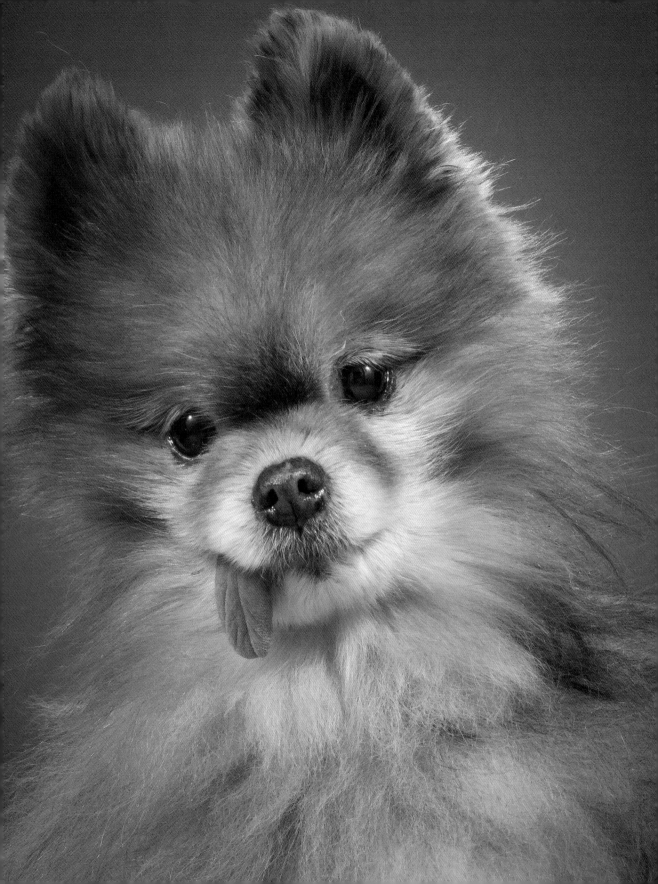

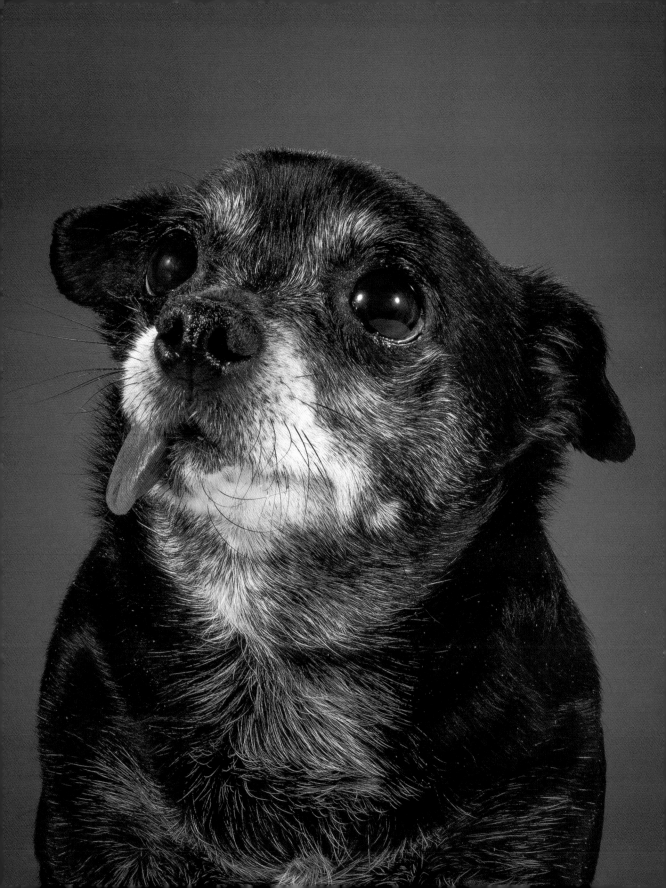

# Missy

MINIATURE POODLE, 15½

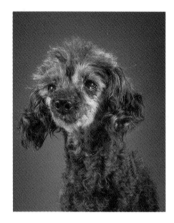

When Missy was about one and a half we almost lost her. It was a very, very hot weekend, and we stayed inside in the air-conditioning most of the time. One early evening I thought it had cooled down enough to take Missy outside to run in the grass—which she loved. She was so happy to be outside and took off running around the house. But once around the house was apparently too much for her, and she collapsed at my feet. I did not have air-conditioning in the car, and lived outside of town, so a ride to the vet would have taken about forty-five minutes. Instead, I laid her on the cool hardwood floor, wet a facecloth and laid it on her like a blanket, and wiped her down. I tried to give her water—no luck. Desperate, I put little bits of ice cream in her mouth, and slowly she managed to swallow. Then I gave her watermelon, then water. It took about six hours for Missy to look and behave completely normal.

Missy, like most dogs, loves food. Her favorite "human" foods are green beans, watermelon, cheese, oranges, and pizza crust.

Missy loves all other animals, especially cats, and doesn't understand when they don't feel the same. She loves people too—friend, family, or delivery person, she will "talk" to everyone until they acknowledge her, then they get a lot of kisses.

Missy has started to slow down. She has had to have all but six of her teeth removed (hence her crooked little smile). She is now partially blind, deaf, and has arthritis and dementia. She can't get up on the furniture anymore, and we carry her up and down stairs, as she sometimes stumbles.

Missy isn't good with math and has no idea what "senior" means, so she still often behaves like a puppy, running and playing,

which makes us and her happy, and even though playtime isn't as long as it once was, she's still up for it every day. Since she has lost vision and hearing she seems to have gained other senses.

Missy loves the nice weather. She uses the cracks on the sidewalk as imaginary barricades that she must "fly" over like a pole-jumper.

Missy has been with us fifteen plus years now, and we are hoping for as many more as we can get as long as she is still wagging her tail happily and enjoying smelling the flowers.

She's our happy/hyper/cuddly and always-faithful old doggie.

SUSAN INACIO

# Lucky

SCHNAUZER, 15

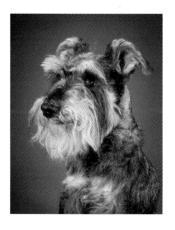

Four years ago Lucky was attacked by two American bulldogs. The vet said he probably wouldn't survive the night due to blood loss, but Lucky greeted them with a wagging stub-of-a-tail the next morning! The vet said he'd have a punctured/collapsed lung. Nope! The vet said he'd lose an eye. Still uses both. The vet said he'd lose a leg. Lucky doesn't even limp on a rainy day.

He is mostly deaf now, his vision is only so-so, he needs help to jump on the bed, and he lost most of his teeth . . . but he's my little buddy and still the master of cuddles.

PHILIPPE ESCAYOLA

# Ava

GERMAN SHEPHERD MIX, 9

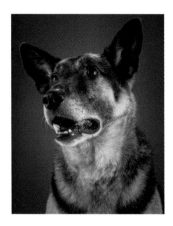

Ava, a nine-year-old German shepherd mix, was rescued from a farm in southern Manitoba. The farmer had threatened to shoot her and her sister. I was lucky enough to find Ava at a local rescue and take her home at six months old. She was terrified of men, brooms, sudden movements, and loud noises. She has come such a long way since then, becoming a sweet and loyal friend.

From the moment I took her home, I would take Ava to work with me. I was an equestrian coach at a nearby horse stable. Ava got to play with other dogs and meet many, many friendly people. This socialization was an important part of her training. Ava grew up playing with children at summer horse camp and was trained to jump fences. Some people at the stable were leery of German shepherds, but after meeting Ava, they were no longer threatened by the breed. She loved belly rubs from the campers and wowing the spectators at horse shows.

Unfortunately, at the age of thirty, I had to retire from coaching due to multiple sclerosis. This meant that Ava also had to retire. She was a bit depressed at first, but now she enjoys reclining on her own couch, going for walks or bike rides with me, and playing with my other dog, Molly. They have even played so hard that Ava chipped her canine tooth and had to have it removed.

I'm not sure what I would laugh at daily if it weren't for the generous, goofy, trusting love from Ava all these years, especially when I have to sit at home, frustrated and off work for months at a time recovering from a relapse of multiple

sclerosis. When I feel my worst, Ava senses it and comes up to me, rests her head in my lap, and gives my hand a couple of licks to tell me things are going to be all right. Ava has earned all of her white whiskers and is truly one of my best friends.

BRENDA GIESBRECHT

# Murphy

FAWN GREAT DANE, 10½

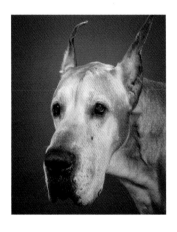

Murphy is a ten-and-a-half-year-old fawn Great Dane. Originally a champion show dog from Florida, Murphy came to live with me at the age of five. I continued to show him, in obedience, not conformation, but soon realized that it simply wasn't his calling. His true calling was to be a therapy dog. We were given the opportunity to work with a mental health program at a children's hospital, but we didn't work through a therapy dog organization—the hospital insured Murphy as an actual volunteer.

He has been retired from therapy for two years now, but he still has quite the following. Every Sunday at 6:00 p.m. from May to September, for four years, Murphy sat on the waterfront, in front of Murphy's on the Water, fund-raising—often joined by other dogs. This began with work for the SPCA and recently switched to support Fresh Start Dane Rescue. Last summer was Murphy's last on the waterfront, as he now has a degenerative disease that makes it impossible for him to stand for very long. The work on the waterfront will continue in memory of what Murphy started and for all the rescues he has helped along the way and that will be helped in the future.

SANDI LEAF

# Dash

DACHSHUND, 17

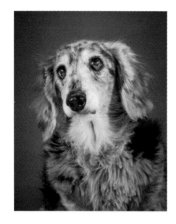

Dash is a seventeen-year-old long-haired miniature dachshund. Dash's favorite foods are cheese, cucumber, bread, and anything else that happens to be in the garbage. He has always loved running in the backyard, playing with other dogs, and going for walks at the duck pond; although these days, he more enjoys watching TV with his family and sleeping in his bed in the sun.

We got Dash when he was one, and for the first year of his life he had been a show dog. He was super healthy, playful, and energetic, until one day we could tell Dash wasn't feeling well, so we took him to the first of many vet appointments. At eleven years old, Dash had to have two major surgeries in one week. A few years later, Dash became unable to walk. The vet told us Dash required another surgery, and that the best-case scenario would be that he'd be able to walk again, worst-case scenario that his hind legs would be paralyzed and he would have to use a doggy wheelchair. We tried acupuncture for Dash, and after a couple of times he was able to walk again. Now, at seventeen, Dash still has so much energy and life left in him. We love how strong and how much of a trooper he's been throughout the years!

He has had a long, happy life and continues to be a loyal companion who loves cuddles and kisses.

CASSANDRA BERTI

# Kava

MINIATURE PINSCHER, 13

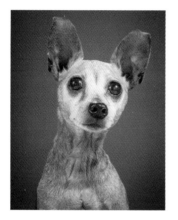

Kava, aka BABO, has been a trooper from day one, having been born with debilitating bone disease that she overcame. Today her little front paws are crippled by arthritis, and her back legs are pretty much useless, yet she continues to pull herself around her little world she calls home. The most amazing thing about Kava is that she has never complained. You can always find Kava by looking for the sunrays. She will be stretched out, suntanning, her eyes closed, and a smile on her face.

RENOTCKA WAGNER

# The Fritz

MINIATURE PINSCHER, 16

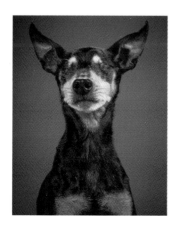

This amazing little guy overcame immune-mediated thrombocytopenia ten years ago, undergoing a total blood transfusion thanks to a donor. Recently he had both eyes removed but has adjusted wonderfully. He still likes to walk around on his own, albeit slowly and carefully, instead of being carried. Fritz is as independent and social as ever, always greeting visitors, especially cozying up to the ladies. Fritz is my dog and will have forever a special place in my heart.

RENOTCKA WAGNER

# Pumpkin

POMERANIAN, 17

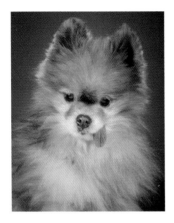

In 2010, Pumpkin's owner passed. My daughter is a vet technician, and on occasion will groom dogs at our house after work. She brought Pumpkin and her siblings home one weekend to bathe and clean them all up to try and find homes for them. I fell in love with them, and she talked me into adopting one. I reluctantly agreed and chose Pumpkin, a twelve-year-old toothless, deaf, untrained little dog whose tongue hangs out the side of her mouth.

Pumpkin has become the baby of our household, and we tend to her every need. We take her everywhere with us. She is seventeen years old and gradually slowing, and now her vision is not as sharp as it used to be. She is now refusing to eat much at all. She is hand-fed and we spend every evening trying to coax her to eat some food, sometimes even buying roasted chickens and cooking hamburger meat for her.

Pumpkin still gets excited when we come home from work, and she is happiest when we go to bed and take her with us to sleep in the big bed. She is a beautiful little dog and is loved by everyone she meets.

KIM BURGESS

# Sam

CHIHUAHUA, 17

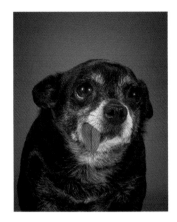

I got a call from some folks at a rescue group that I had done some fostering for in December 2009 and they said they needed some foster parenting for some small breed dogs coming in from a puppy mill. I showed up, and they said they had one Chihuahua they had named Rotti, and they were keeping him in the washroom because he was fighting with all the big dogs over the females. They mentioned that he was an older dog (between ten and twelve) and that the vet was running some tests because his health wasn't great. They brought him out, and my heart melted. A couple of days later we got word that Sam, as he was now called, was pretty sick and was only expected to live three months, so he wasn't going to be adoptable. I said I would keep him until that time so he would have a home to be comfortable in. It's been five years now, and he is the most lovable old man imaginable. I wouldn't trade the last five years for anything! A mother's love can heal all, but I think Sam did some healing on me.

LISA EVANS

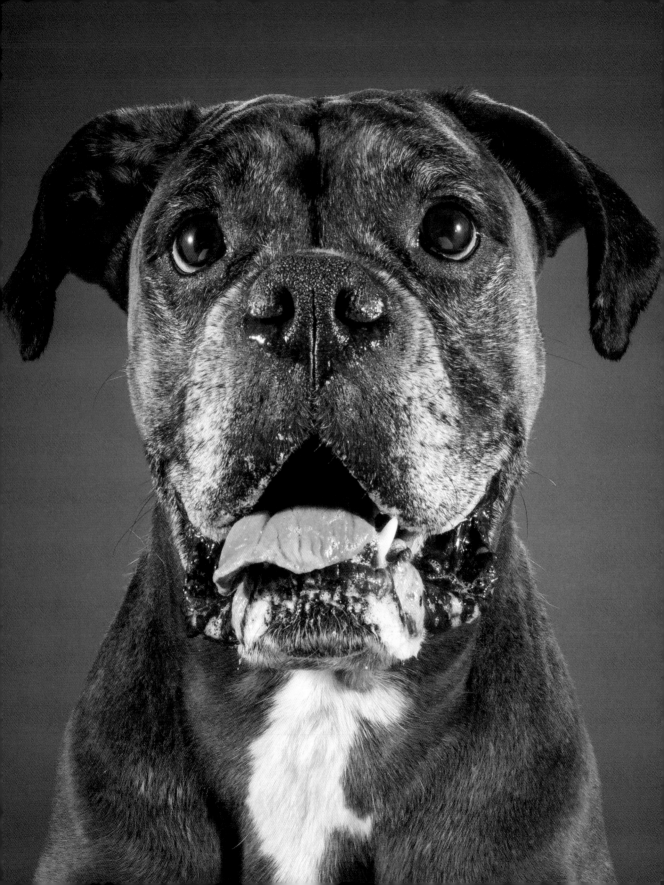

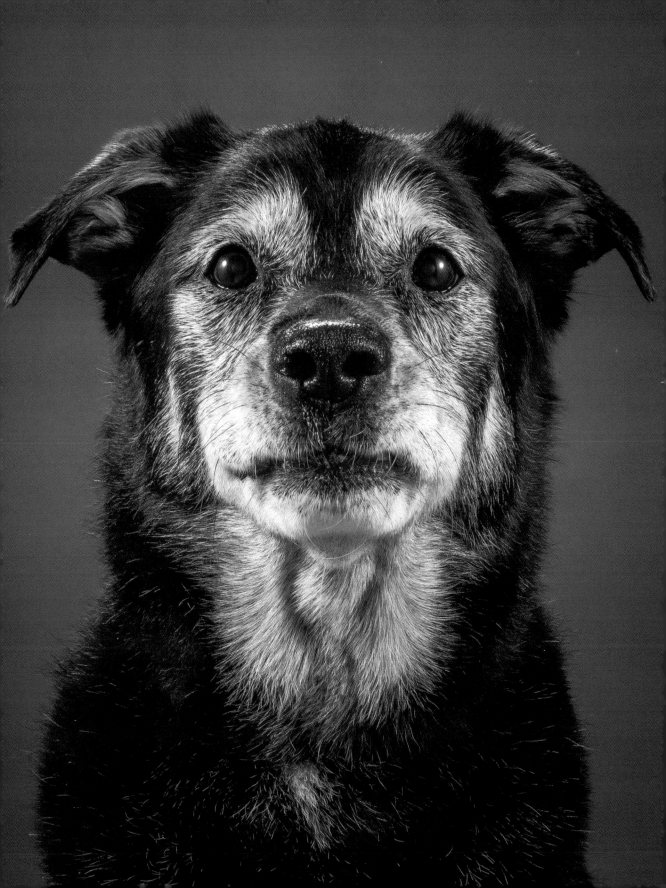

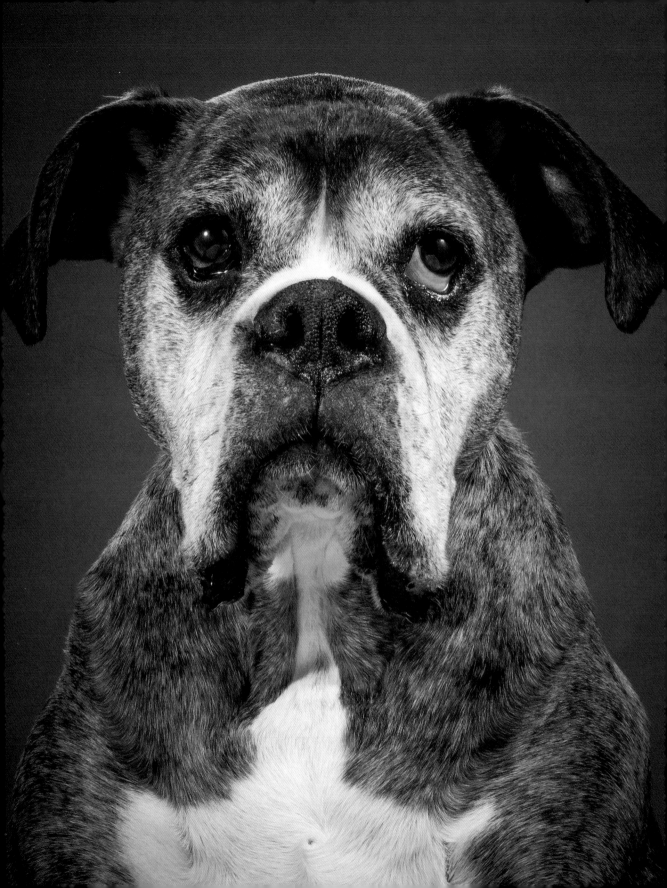

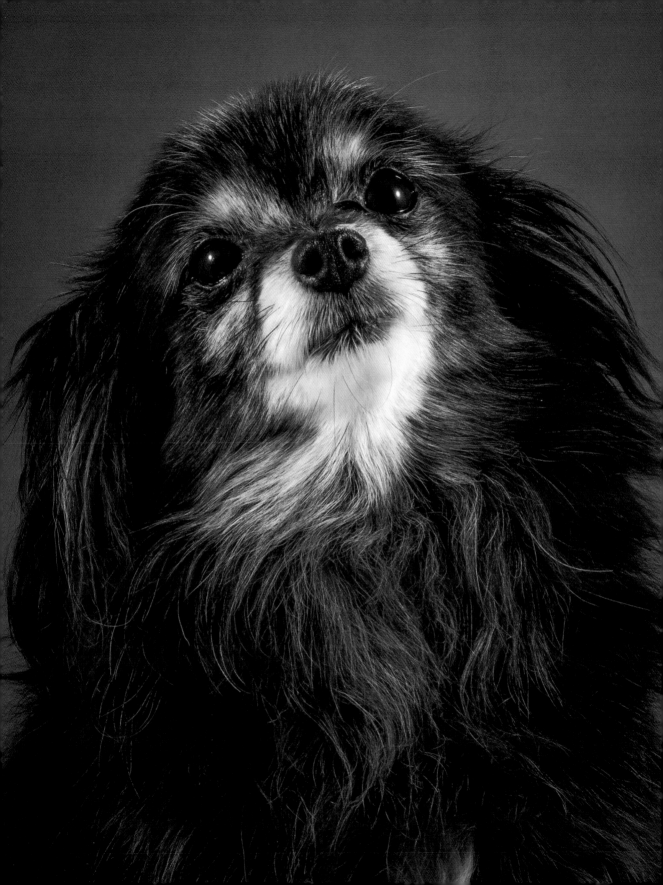

# Rhome

BOXER, 7½

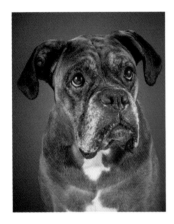

How do I put into words the way I feel about Rhome, a dog that has given me so much of himself and asked nothing in return? It may not be possible to truly capture with words the love and bond that a boy and his dog share. It's a connection that surpasses all shackles of conservative thought, because as long as you have your dog, you can do anything.

Seven years ago I picked Rhome out of a litter of twelve boxer puppies. They were all adorable, but there was something special about him. Maybe it was the twinkle in his eye or the way he wagged his little tail. Whatever the reason may have been, I know for sure that it was fate for him and me to meet on that day, and he has had a great life ever since, blessed with good health and high spirits.

Rhome has not left my side for the last seven years. He sleeps on my bed at night; he's my workout partner and enthusiastically encourages me to go for runs, even when I don't feel like it. He shares my meals, even when I didn't know that we were going to share that meal.

Times goes so fast, I am grateful for the time he gives me. His aging has a wonderful beauty. Over the years, he has taught me the meaning of trust, loyalty, friendship, tolerance, and, as he has gotten older, faith and optimism.

I could not imagine my life without Rhome. He's been slowing down as of recent, so he's not as fast as he once was. His once pitch-black mask is graying, a constant reminder that Father Time waits for no man, or dog. I will always love my best friend, Rhome. He is the true definition of "man's best friend."

CHRIS KEMP

# Jackson

LAB-ROTTWEILER MIX, 12½

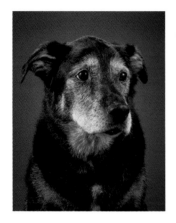

My husband and I got Jackson from the SPCA when he was only three months old. He was the only dog in the pound not barking. He was sitting in his cage perfectly upright with the saddest face. You couldn't help but be drawn to him. We took him for a walk, and the connection was instant. We could just tell this guy was a keeper, and adopted him immediately.

Jackson is a remarkably active dog given his age (he is twelve and a half now). He adores car rides with his head out the window, playing ball for as long as you'll let him, and diving into pools and swimming endlessly. My husband, Jackson, and I have been the three musketeers for twelve years, so I think Jackson thinks he's a human.

Jackson is a very intelligent and attentive dog that's also highly sensitive. He has a heart of gold and a personality to match. He will wait for you wherever you are—whether that's opening the bathroom door to wait at your feet, outside the shower, or under your desk while working. He is always there. And he never loses eye contact with you. When you ask him if he wants to go in the car, or for a walk, he'll do numerous spins in a row to celebrate the outing. Jackson loves naps, playing with his favorite stuffed duck toy, and his favorite treats: carrots, apples, and cheese. He's a real crowd-pleaser and very popular with the neighborhood dogs.

Jackson has been with us for twelve years, six homes, two Canadian provinces, and a million road trips! Jackson is definitely our best friend, and we hope to be blessed with him for many more years to come.

NICOLA DOYLE

# Lexi

BOXER, 11

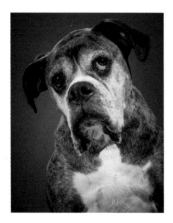

Lexi was a droopy, drooly, lanky, and stressed-out puppy that needed to come home. We don't know her history before that day, but she came to us at eight months old and has led a charmed life ever since. She is growing lumps, her heart has a murmur, and her mouth is full of tumors leaving her with the most god-awful breath. But she is still my happy, playful companion and she makes every day better.

DANA WHALEY

# Pepe

LONG-HAIRED CHIHUAHUA, 10

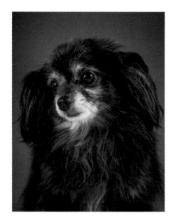

Pepe is a ten-year-old long-haired Chihuahua. When he was born it took a few months for him to find an owner. But once he was brought home, it was obvious that he would be a very loving and loved part of the family. Pepe is a very affectionate dog that always enjoys meeting new people and giving them a lick. Despite his small size, he is not afraid of running through the woods to chase after deer, though a deeply seeded fear of balloons and mops may render him helpless. As a puppy, Pepe had only a bit of white on his chest and his back Grinch-like foot, however his beard and eyebrows have gained a bit more white with each passing year to give this old man his distinguished look.

BLAINE McINTOSH

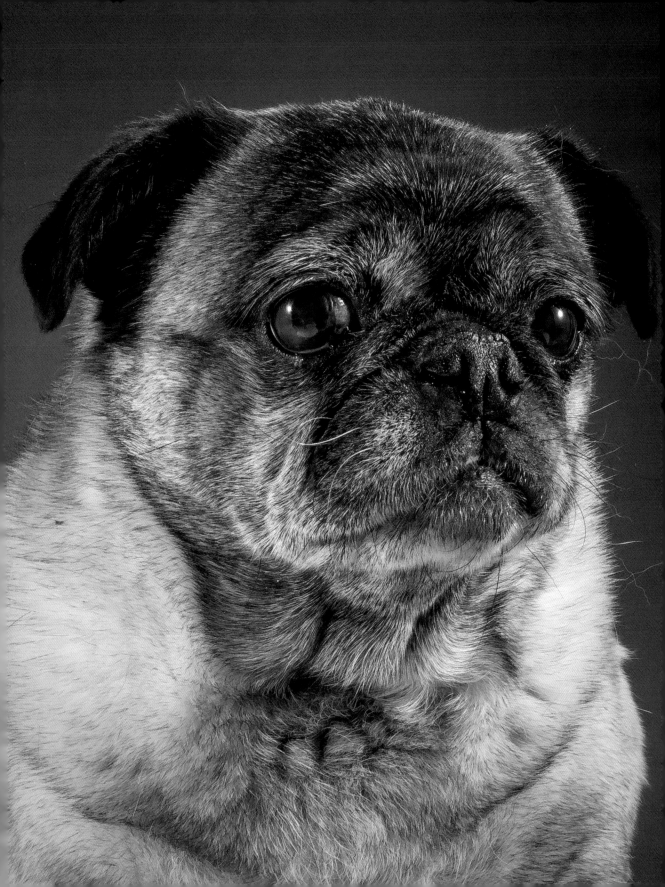

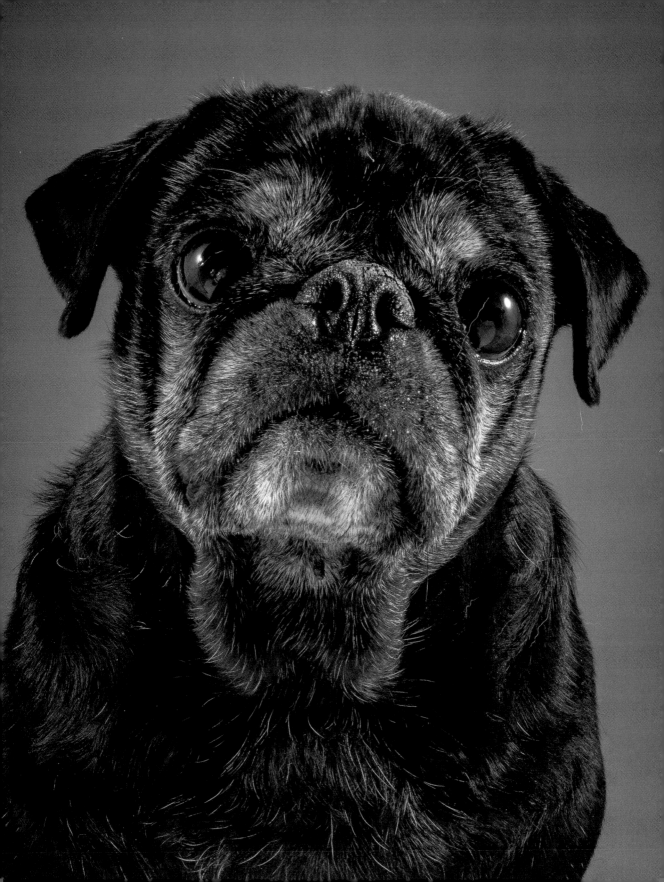

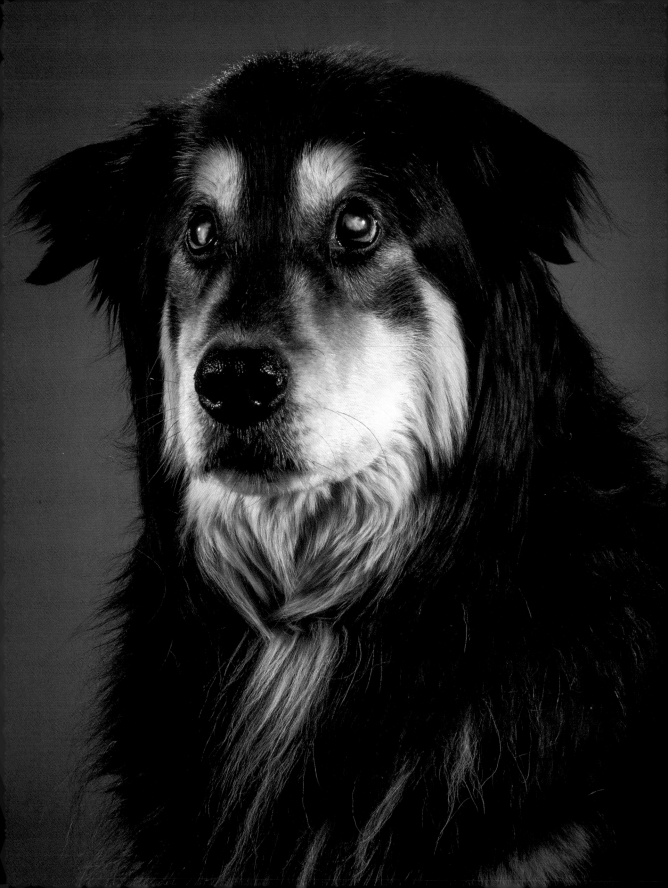

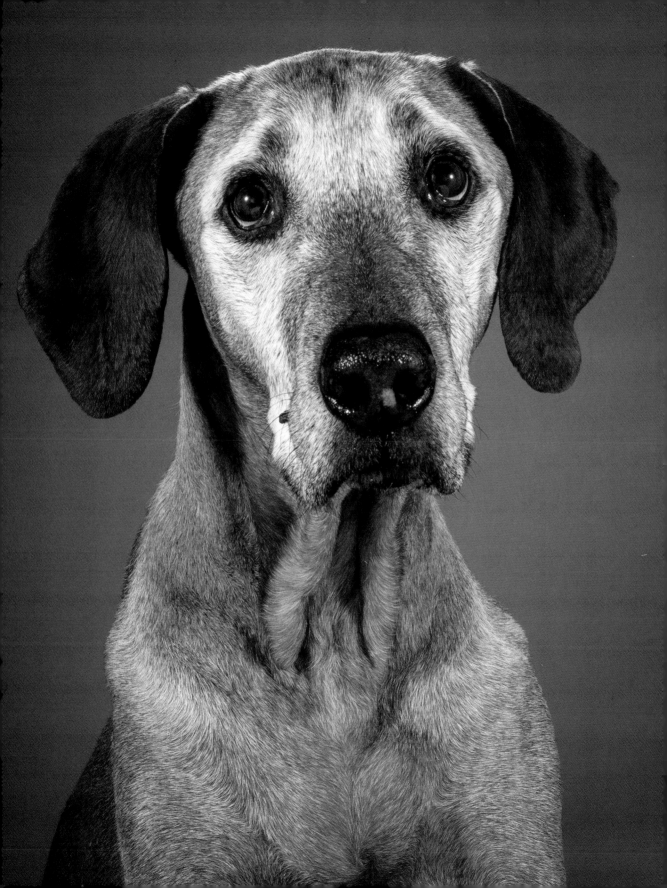

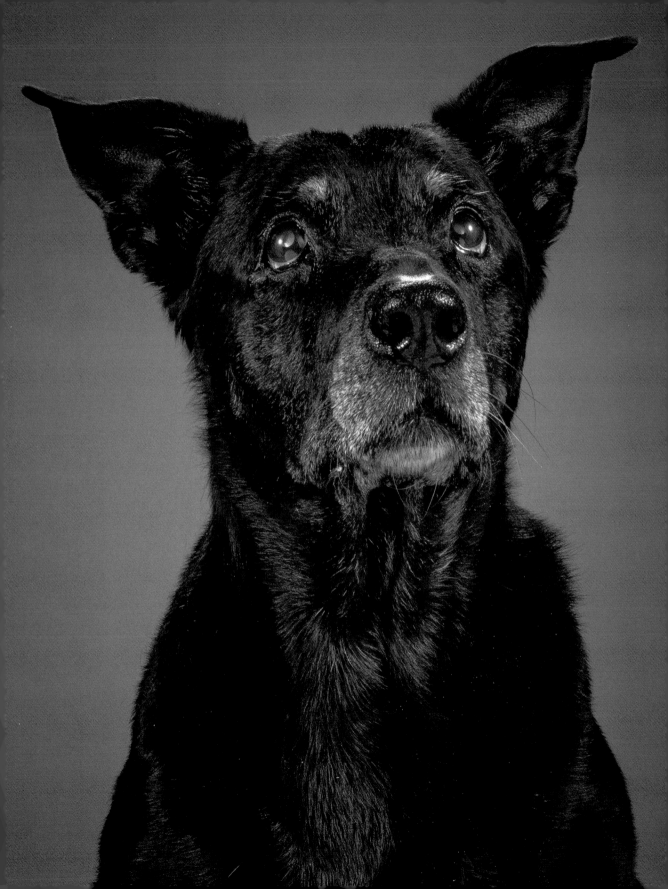

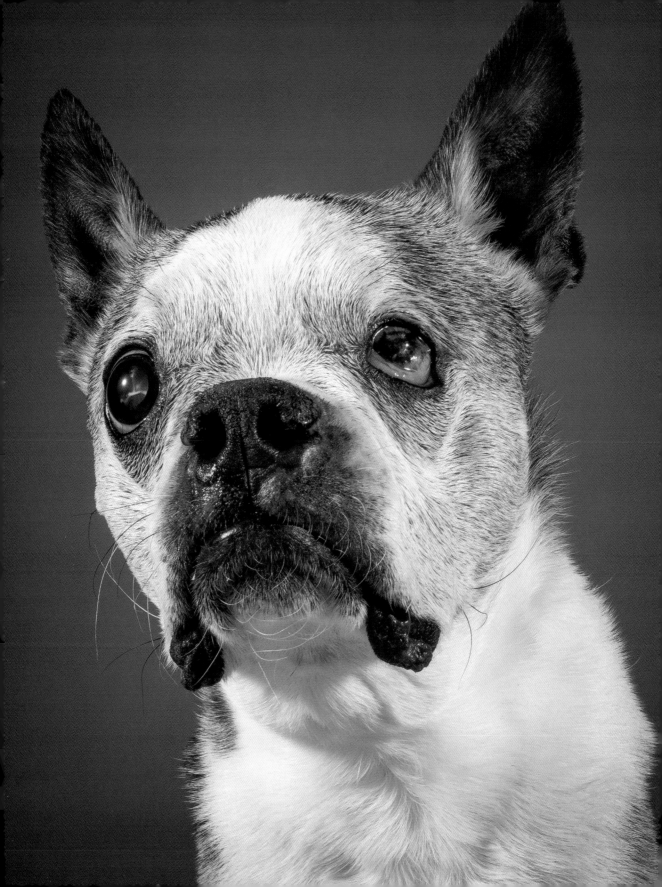

# Kricket

PUG, 14

Kricket was three when we brought Diesel home. They loved each other from first sight. They can be found sleeping on top of, under, and intertwined with each other. They are truly joined at the hip. They went on to parent three beautiful litters together. Long since retired, they never once contemplated divorce.

GINETTE VANROOSE

# Diesel

PUG, 11

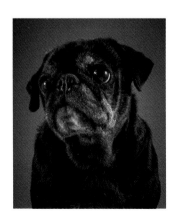

Diesel sleeps . . . a lot. Often up to twenty hours a day. Anything left on the floor becomes his bed, even though he has multiple real dog beds. He has been seen sleeping on the clothes in a hamper, a teddy bear, a sock (yes, one sock) and even a piece of paper that he will try to fluff up before lying down on it.

GINETTE VANROOSE

# Colby

BERNESE MOUNTAIN–BORDER COLLIE MIX, 12

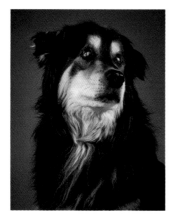

When I went to the SPCA I was specifically looking for a small dog that didn't shed, but somehow I left with this eighty-pound shedding machine. I just couldn't resist his sweet face and charming personality.

When we got our second dog, Dawson, Colby immediately took on a more mature role in our family. With a quiet authority, he somehow manages to keep Dawson in check (which is no easy feat) so we've taken to calling him the Manager.

Colby started to lose his vision about four years ago and is now totally blind. However, despite his new obstacles and challenges (including a non-fur baby sister), he has never lost his sweet temperament and lovable personality.

MARY LEDGER

# Tannin

RHODESIAN RIDGEBACK, 13

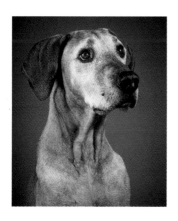

Tannin has been known as the old soul and has earned the name Old Man Tan. He is a rock-steady dog and is always up for something fun or is content to snuggle on the couch—under a blanket of course. Everyone says they picture him on the couch in a smoking jacket with a pipe.

Tannin is also a cancer survivor. He had a mast cell removed from his neck almost three years ago and is now living with bladder cancer. But he is still thriving and enjoying a great old dog life.

TARA DOIRON

# Sadie

BLACK LAB MIX, 14

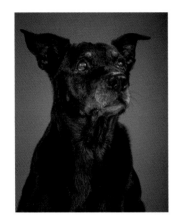

Sadie is a fourteen-year-old black Lab mix. Sadie spends her time being copilot with her human mom, going everywhere together. Doing anything with Sadie is a pleasure, as she is always well behaved and up for doing anything . . . as long as she is with her humans. She enjoys the company of other dogs but would rather spend her days with her people. Sadie shares her home with a younger sister, Zoe the pit bull; four cats; and two horses, all of which adore Sadie so much. Especially Zoe, who follows her around everywhere and tries to be just like her. A few years ago the vet found a huge seven-pound growth and Sadie had to have major surgery to have it removed. She handled it like a champ and recovered well. About a year ago she was diagnosed with diabetes. She has to have insulin shots twice a day, but she is doing well with those now and she still enjoys every day and doesn't seem to let it slow her down. She still enjoys her car drives, short walks, and the occasional game of soccer. Sadie has brought so much happiness and love into the lives of her family. They cherish every moment with her. She's a very special girl. Anyone who knows Sadie loves Sadie. It's impossible not to.

SHAN MISNER

# George

BOSTON TERRIER, 12

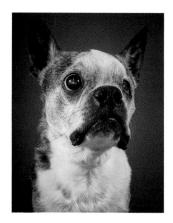

My name is George O'Hara. I am twelve years old, blind in one eye, and see very little through my sort-of-good eye. This does not stop me from playing with every toy available to me. Whenever a human is ready and willing, my favorite pastime is playing fetch. I just need to use my nose and feet to find the ball now. I love to play soccer, and in my younger years had been banned from many soccer fields due to my lack of restraint when I saw a soccer ball being kicked across a field.

Now that I am a senior dog I prefer not to go for walks and play outside in the cold of winter. I am happy curled up in front of a fire, panting for air. My mom says that with my young heart and energy I will be around for a while yet. If possible I would like to travel with my mom to Cuba in the winter. I love the beach and beach balls! I have the shirt and am ready to go.

SHEILA O'HARA

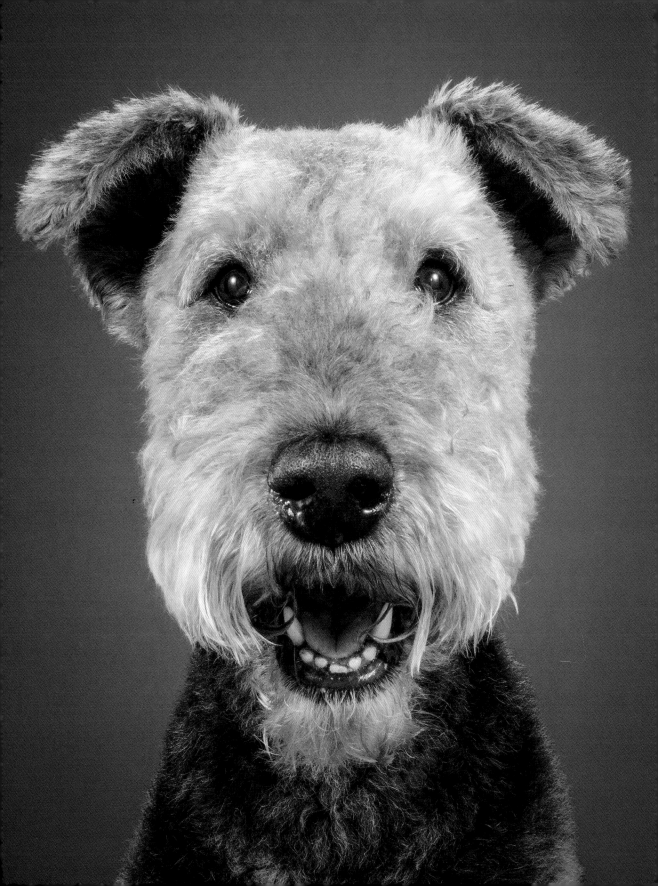

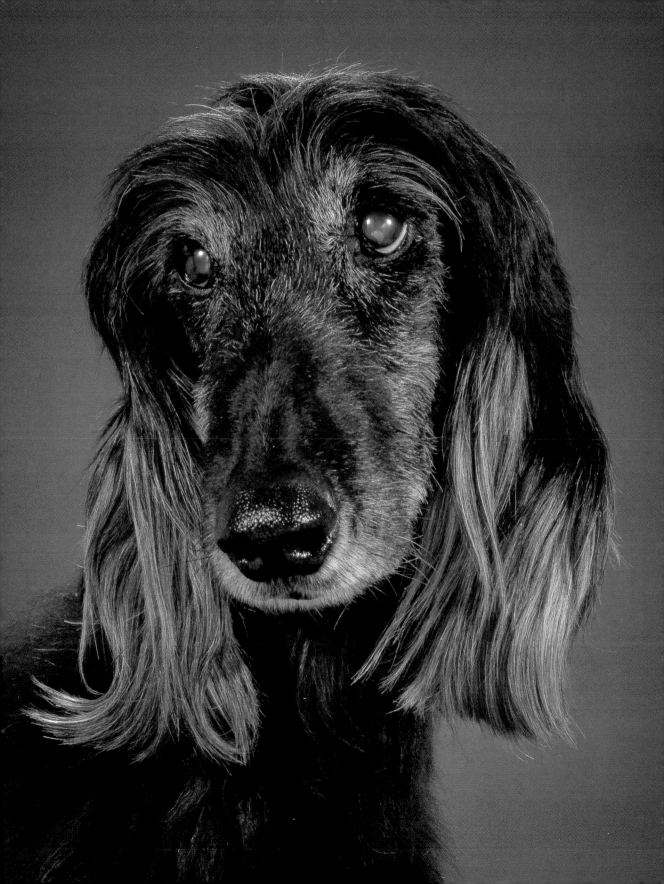

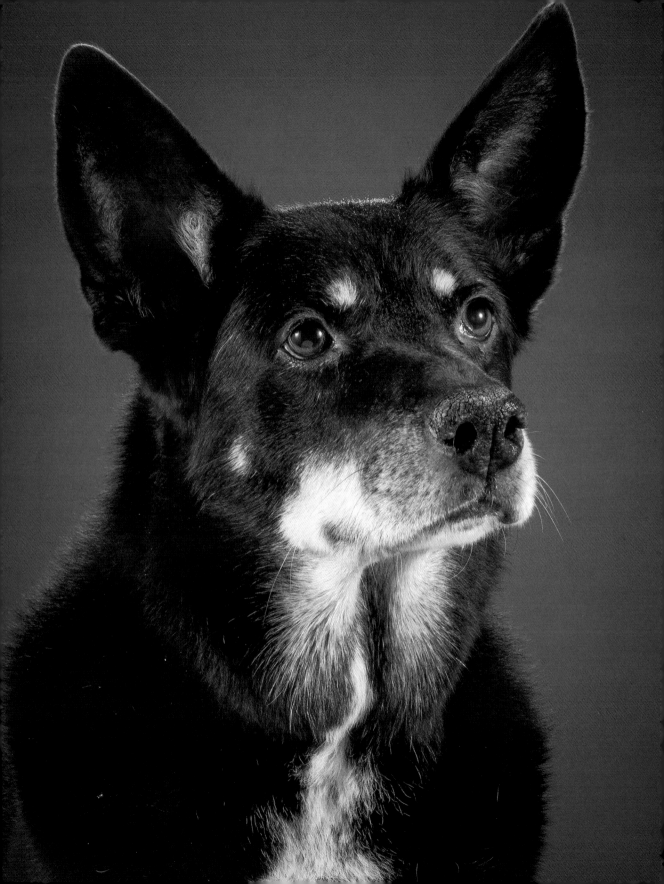

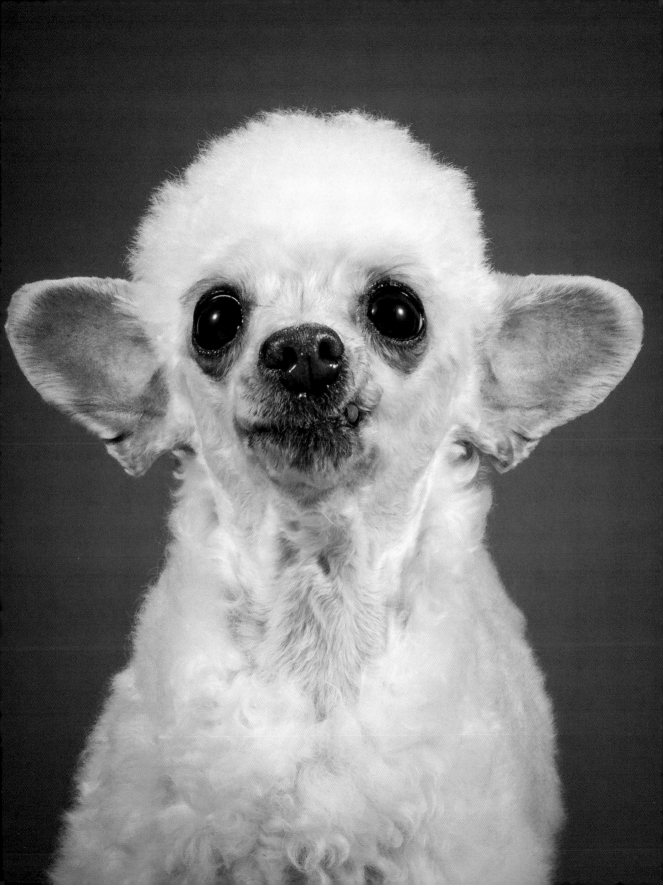

# Stanley

AIREDALE TERRIER, 11

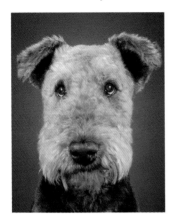

For as long as I can remember I wanted to own an Airedale terrier. I'll never forget bringing Stanley home: he lay on my chest for two hours; we felt each other's heartbeats, bonding.

Stanley is amazing with our three children; he's calm and loving, and the sweetest boy I know. I love his kind eyes and easygoing demeanor—Stanley is a lover, not a fighter. He adores squirrels, and after three stinky run-ins with skunks, he still doesn't understand those meetings never end in his favor.

Stanley is eleven now, but his health has always been a challenge. Three of his four legs have had major surgery, he's allergic to all meat, and he has congenital heart disease. His heart disease is taking its toll; my boy is aging fast and it breaks my heart. I need more time to stare into his kind brown eyes.

TAMARA TAGGART

# Racket

AFGHAN HOUND, 16

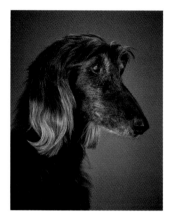

Racket is a sixteen-year-old Afghan hound, born November 15, 1998. The Afghan hound is an intelligent, dignified, and aloof dog: independent, proud, loving, and devoted. Racket is every one of those things, even more so in his old age. He followed his sister into our home, arriving a few months past his first birthday. He was a very shy, sensitive dog, but to us he was nothing but loving, sweet, gentle, and ever the good dog.

He will drink only out of certain bowls, bones can only be served on the floor, never out of a bowl. He loves ice cream but once refused to eat a generic brand, since a friend had Haagen-Dazs, so *pffft* to that. He will eat only crispy biscuits at night before he goes to bed, and jerky can be eaten only in the morning. It's not that he's spoiled, that's just Racket. I am proud to say that over time he grew more confident and had a successful show career, earning his Canadian and American championship titles, including a National Specialty Award of Merit and a Best in Specialty Show award. He also earned a Canine Good Citizen title and a Junior Courser title. At sixteen years old he can still jump up on the bed, loves to go for a walk or run, and most of all just loves to be by my side. The greatest feat in his old age is putting up a valiant fight and surviving emergency surgery for bloat at fifteen years of age. He is the dearest, most devoted companion, loved beyond words, and we cherish each and every day like it might be the last.

LYNN WOODS

# Scout

DOBERMAN-KELPIE MIX, 12

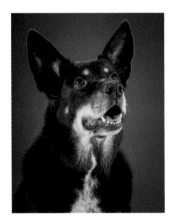

I remember Scout's indifference when I approached her kennel at the Humane Society for the first time. It was as if I were one of many who had walked by her before, stopped to admire those ears and eyes, and then walked away after reading the handwritten note on her profile card that stated RETURNED. It was as if Scout knew better than to get up her hopes. That was when I took her home.

The first time I brought her to the dog park, her recall was okay at best and I was reluctant to take her off her leash. What-if scenarios kept running through my head. The group of walkers around us were joking about how, the weekend before, a bunch of dogs went running after a poor rabbit. My heart lurched at the idea of Scout chasing a rabbit into the woods and then never returning to me when I called her.

During our walk, Scout's extending leash kept tangling around one woman's legs. Understandably she was getting annoyed, in spite of my apologies and explanations of "she's new here, sorry, sorry!" If Scout and I were going to be allowed to continue to walk with these nice folks, I knew I had to take her off her leash. I bent down and whispered to Scout, "Please, please, please don't run away," and I clicked her off her leash.

I watched my girl run full tilt ahead of our pack and I held my breath. She ran to the ridge of the hill we were climbing . . . and then she stopped and turned around to look at me. Her ears pointing straight up, her tongue hanging out, and she was positively beaming. A man walking in our group sidled next to me and put his hand on my shoulder. "I wouldn't worry, my dear. Do you see how she runs just far enough that you're still

in her sight line? She's keeping you in her sights, perhaps more so than you are of her. After all, she doesn't want to be abandoned ever again. She's not going anywhere without you."

And with these words, my heart sighed with relief and I let out my breath. It was true. Scout never let me out of her sights, never once that day. And never since.

SARAH-JANE MARQUEZ-HICKS

# Hughie

TOY POODLE–CHIHUAHUA MIX, 12

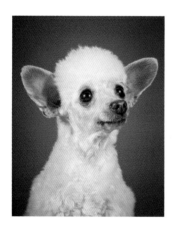

LIKES: his squeaky chicken and his favorite treat, ice cream

DISLIKES: mean people and bees

BACKGROUND: Hughie, nicknamed Choodle came to us in very poor shape covered in mites and fleas and underweight. His nails were so long they curled right back up into his paws. Due to poor dental care, all of his teeth were removed, giving him a fantastic tongue that hangs out from time to time. When I first groomed him, he was a perfect little fellow and gave kisses all the way through. The mites were so bad that his ears were matted to his head, but once the mites were gone, those magnificent ears popped up . . . and his tiny tail has not stopped wagging since.

AMANDA LAYTON-MALONE

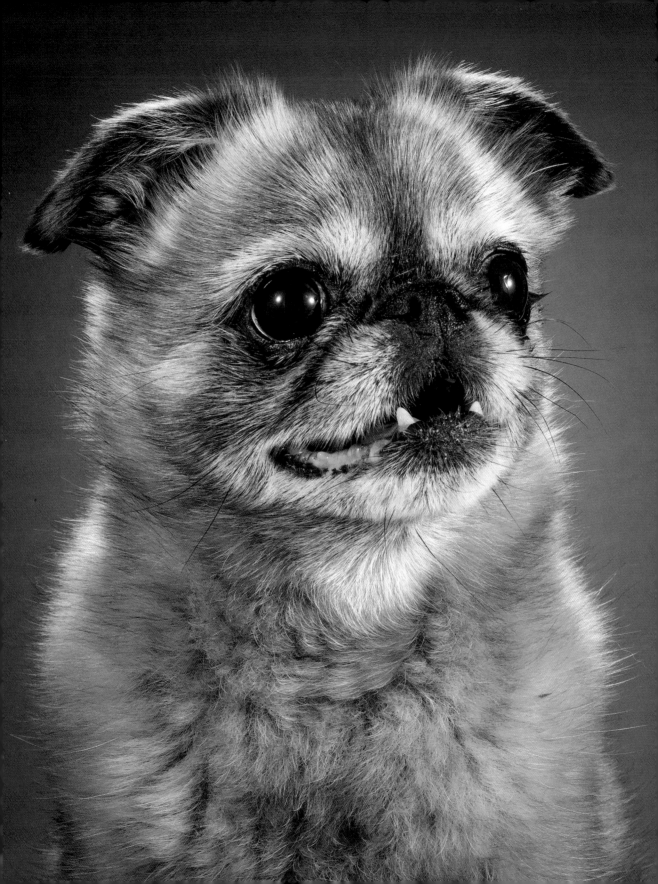

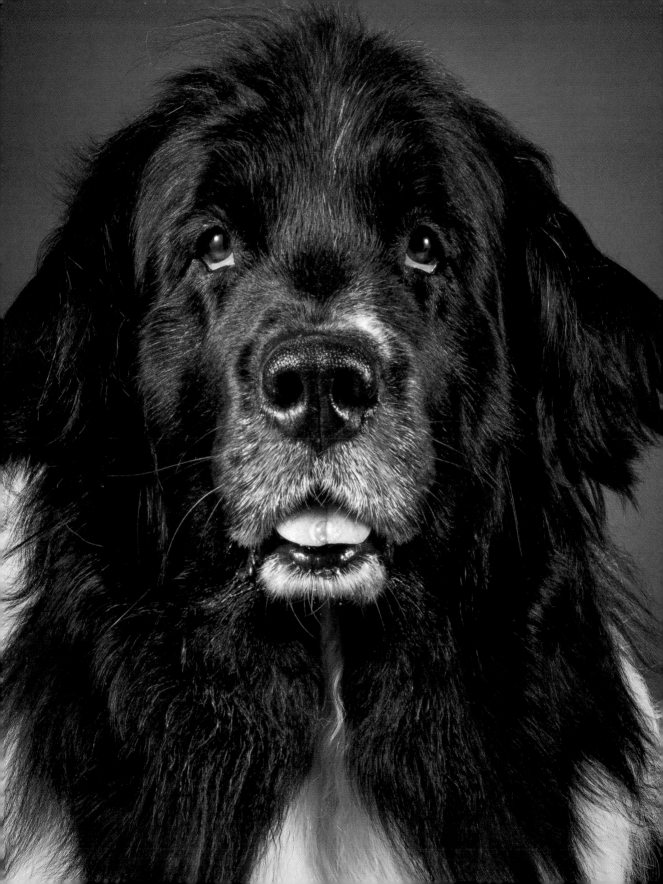

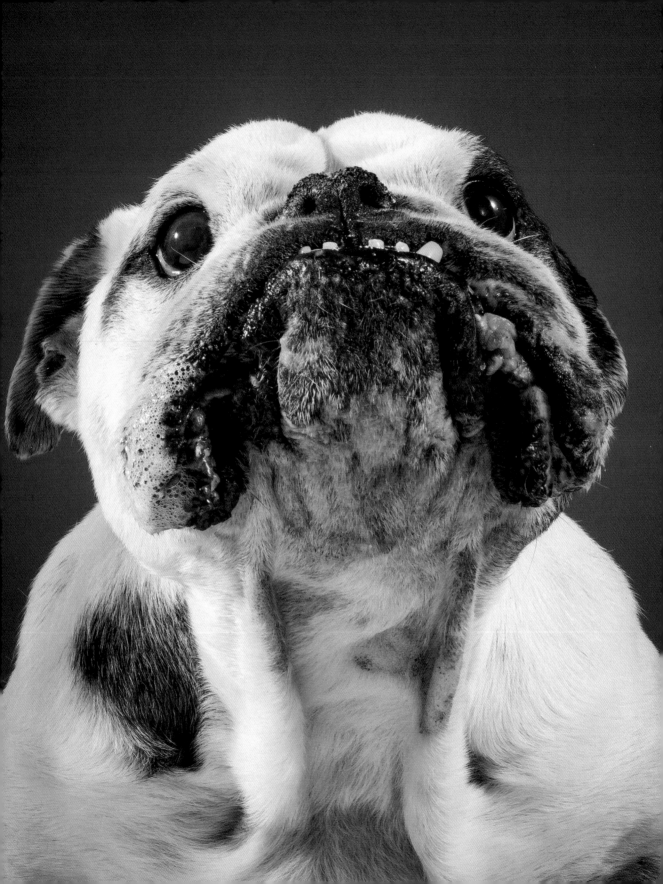

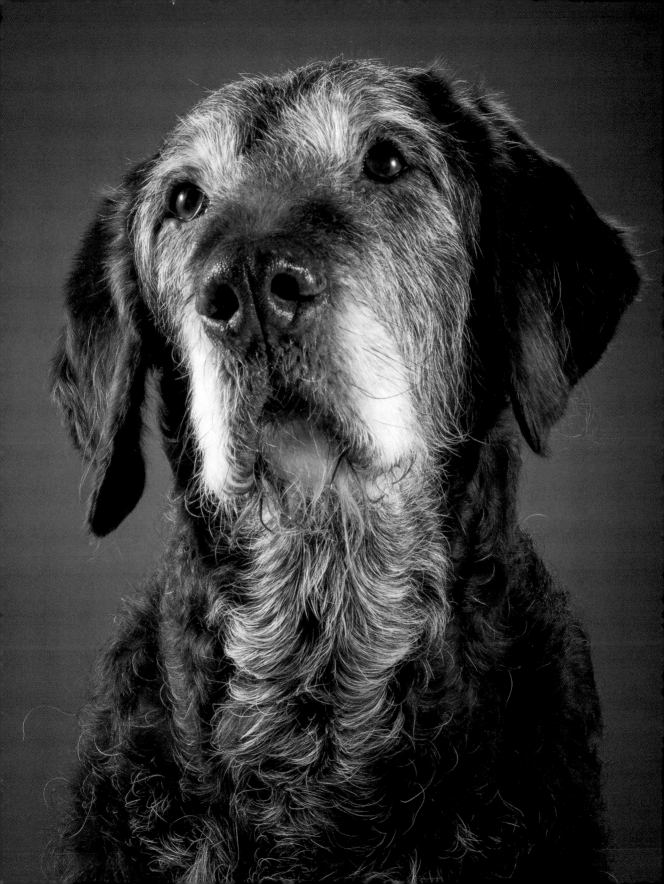

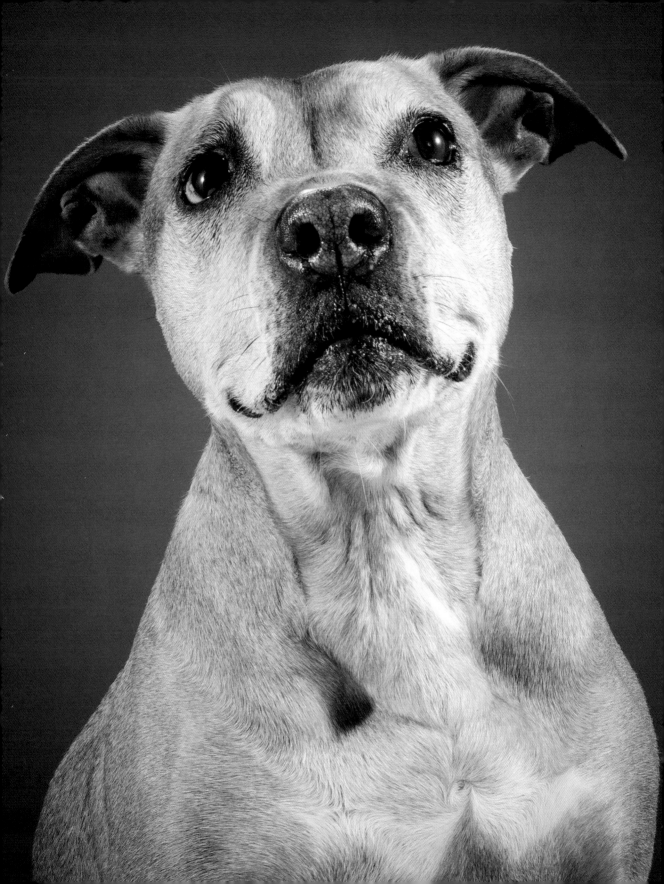

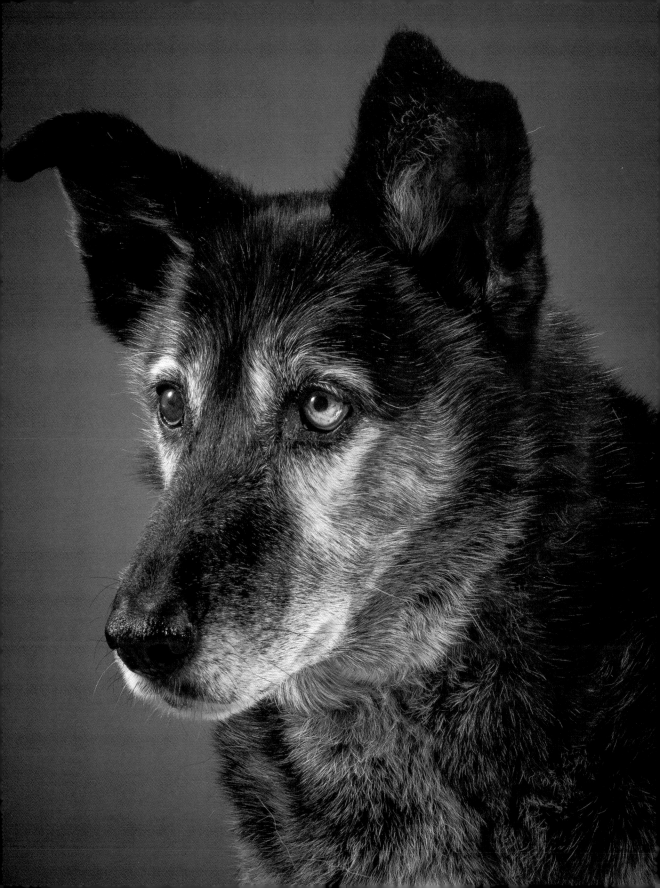

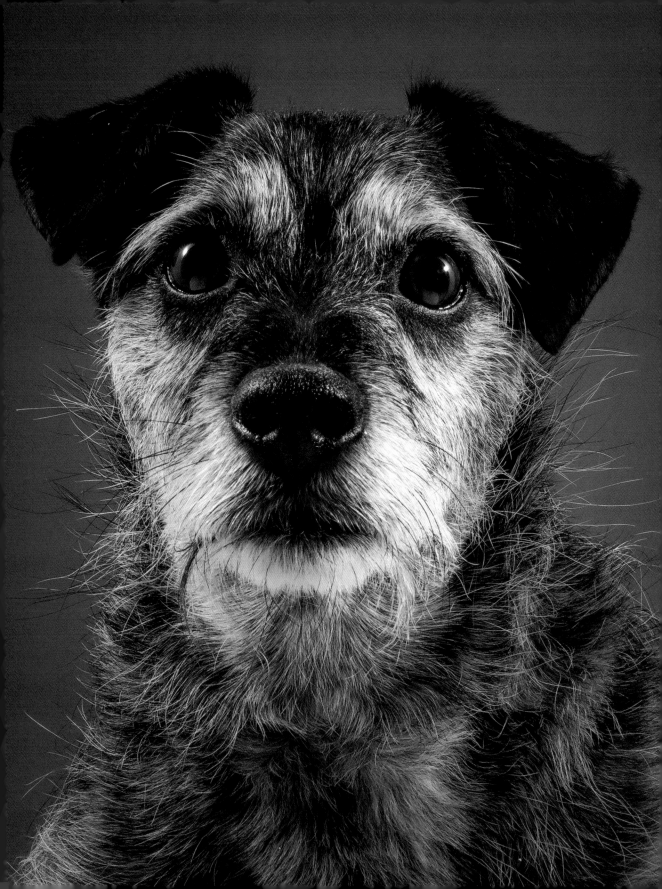

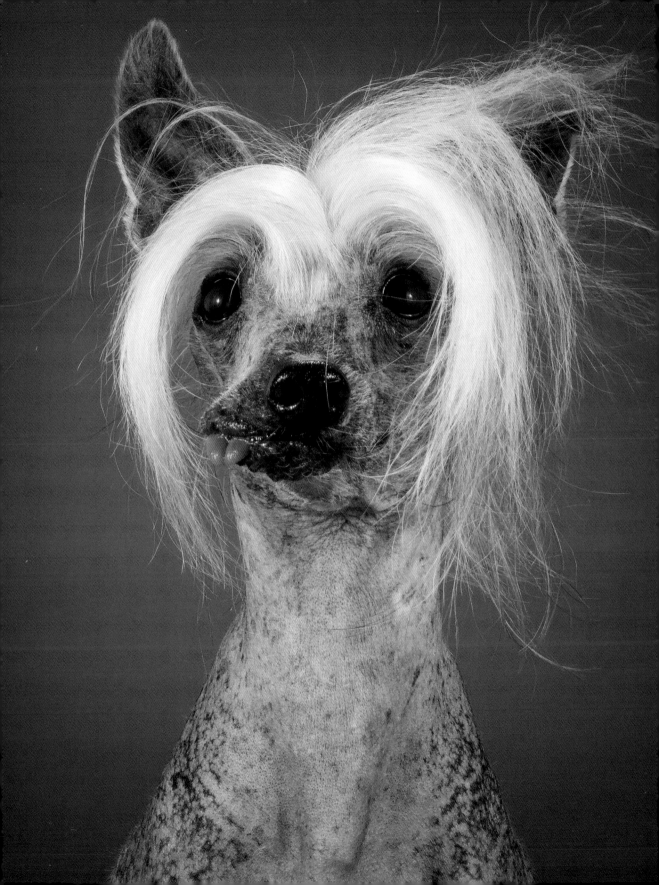

# Finnegan

BRUSSELS GRIFFON, 13

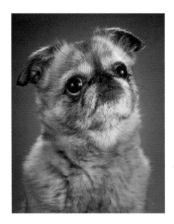

Finnegan has a heart murmur, and has had multiple teeth pulled, but otherwise he is in great health for his age.

He is a smooth-coat Brussels griffon, or petit brabançon. He was born January 29, 2002 and came to live with us at twelve weeks old. Months later, we were preparing to make a cross-country move, and I was chatting with my husband online. Finnegan scratched my leg to ask to come onto my lap. He stepped on the keyboard and typed out "lpoooooooooooo."

When we moved to Montreal a few months later, he was still a young pup and was eager to learn new tricks. We decided that he would also go by his new chosen name Finni Le Poo. Le Poo was a popular pup in our downtown neighborhood. People would often ask to meet him, ask his breed, and give him a scratch behind the ear. He frequented a dog café named Cookies and met many new friends. He even had some fans. One day we were walking Finnegan down the main street, when a car of young women drove by and yelled, "Finnegan!"

Finnegan is currently enjoying his golden years in Toronto. He enjoys meeting new friends, taking naps, and using his new senior dog stairs to get into bed at night.

TRACY LEWIS

# Sadie

LANDSEER NEWFOUNDLAND, 7

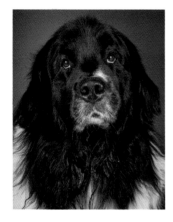

Sadie is a seven-year-old Newfoundland. She is the first senior dog I've had. I was hesitant to rescue her at first because of her age, and because a Newfoundland's life span is ten years on average, but she had me at hello. Her back legs shake, she's slow to get up, her bones crack and snap, she needed dental work, and senility is setting in. But I am here for her for no matter what. My mission is to make her golden years the best years of her life. Like a human senior she is up early and full of beans, but come 4:00 p.m. she's down for the night. Her bottom teeth are kinda snaggled, and after a few extractions her tongue doesn't hang straight anymore. She loves the car like nothing else. Sometimes she brings a toy or my slipper for the car ride, otherwise her big Newfie head is out the window with her snaggletooth grin and flapping heart-shaped tongue blowing in the wind.

LAURA DUCHARME

# Norman

BRITISH BULLDOG, 12

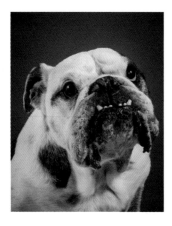

Unlike most rescue dogs, Norman was not abused or abandoned. He was owned by a loving family, and he was spoiled rotten. But he did not like the new baby in the house. That is how Norman came to live with me. In the almost eight years that I have had Norman, no one could have predicted how he would affect my life. He has more medical problems than most vets would have anticipated, as well as an uncanny need to swallow nonfood items. He has had six endoscopy procedures (the sixth one the specialist did for free—seriously), three foreign-body surgeries, and multiple induced-vomiting sessions. On top of his desire to eat things (mostly balls), he has horrible environment allergies, inflammatory bowel disease, arthritis, and in the last few months has been diagnosed with heart disease, a splenic mass, kidney stones, and Cushing's disease. And being Norman, he can't tolerate most of the medicines to treat these conditions. However, when you meet Norman, he shows no signs of sickness at all, and he has never once complained.

I wish I could say Norman is a loving and happy dog, but he really isn't and never has been. It's just not his way. At four years of age, he already seemed like an old dog. Most people would describe Norman as cranky, ornery, dominant, and, frankly, a jerk. He especially likes to pee on other dogs' beds when we are visiting them. He has had no doggie friends most of his life. Most dogs dislike him because all he wants to do is hump them. Puppies tend to like Norman, though, as they don't seem to notice his bad attitude. He has had a few cat friends over the years, but overall, I would call Norman a loner. He does his own thing, at his own speed (slow), on his own terms.

He likes walks, but they aren't his favorite. He loves the cottage, where he can spend hours wading in the water digging at rocks. He can't swim and has almost drowned on a number of occasions chasing a ball into the water. He has a life jacket, but his head is so heavy, the life jacket doesn't work. Norman and I are almost inseparable. He has flown across the country, gone on road trips, and takes it all in stride. Norman doesn't have an anxious bone in his body. He has always gone to work with me, and loves being in the clinic. As an instructor for a vet assistant program, he helps me teach in the classroom. He has become such a presence at my workplace that he has even been given a staff ID badge.

CYNTHIA TODD

# Rory

LABRADOR-POODLE MIX, 11

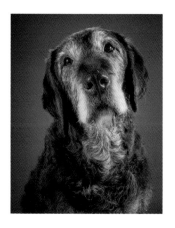

Rory is over eleven and originally from Tennessee. He is part chocolate Lab and part poodle. Originally named for the Irish "red king," his fire color has made room for gray over the years. He's always lived in Ontario, except for when he attended Harvard for a few years (majoring in the Charles River). He is incredibly intelligent (sometimes to our detriment), my daughter's first friend, and an incredible soul. Even in his old age, people continue to stop us in the street to comment on his good looks and give him a scratch.

SHELAGH McCARTNEY

# Copper

PIT BULL MIX, 15

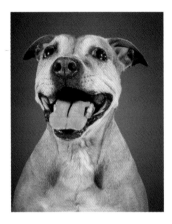

I first met Copper on the last night of her former life. We (animal control services) arrived on a call where there were reports of dogs and puppies locked in a room. Three injured dogs and nineteen puppies greeted us. Two of the three injured dogs were mothers, but all of the puppies were feeding off just one, Copper. Although she weighed only twenty-six pounds (half of her ideal weight), she still fed each and every one of the puppies. As the puppies were being carried to the animal control vehicle, she calmly walked back and forth, making sure each of them was safely transported. Unfortunately all the puppies were ill and passed away. Watching her go through this experience was heartbreaking. On her final day with her puppies, I decided to take her home.

One of my favorite Copper stories demonstrates her unwavering spirit and ability to smile in the face of uncertainty. In June 2013, I arrived home to Copper having an "episode." Something was wrong; she walked outside and just lay down on the deck. We left immediately for the vet, and by the time we arrived, her body was in full shock and all her organs were beginning to shut down. As she lay in the kennel with the IV and heart monitor, she couldn't even lift her head. I thought this was going to be the end.

Anyone who has met Copper knows that she is among the most loyal dogs ever created. If she knew I wanted her to fight (which I was telling her to do the whole way to the vet) she would continue to do so, even if it wasn't what was best for her. But I knew I had to be unselfish and do what was right for her. As she lay listless in the kennel, I told her she didn't have to fight anymore if it was too difficult.

At that moment, she shifted her head from the kennel floor to rest it on my arm, and the tip of her tail wagged for a few

seconds as she looked into my eyes. I knew she was telling me that she wasn't ready to go and that she was ready to fight. And fight she did. She spent the next few days in the hospital. She had multiple EKGs, X-rays, blood work, and ultrasounds done, but to this day, we don't know what caused the episode.

Copper is now fifteen years old. You can see her age in the gray around her muzzle and on her ears. Her sight isn't great and she has lost her hearing. When you grab the leash she can't contain her excitement, and when you take her outside with her Frisbee, you would never guess her age. Copper is loved by her fur siblings, she is loved by all people who meet her, and she is loved by her family. She lives every day as though it is the best day ever and has so many traits that I can only hope I will someday possess. She'll kiss your face as long as you'll let her, will wag her tail as long as she's awake, and will steal your heart forever.

ANDREA FRANCHVILLE

# Tessa Marie Walters

ALASKAN HUSKY, 14

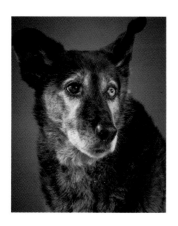

Before finding her forever/retirement home with us, Tessa was a member of a dogsled team. As more of an introverted doggy, Tessa isn't necessarily the cuddliest, but her tolerance for head kisses and squishes is (to our great surprise) constantly on the rise. Some of her favorite activities include eating, walking through the woods, eating, sleeping, shredding paper, eating, and being a generally grumbly and adorable shedding machine.

LEAH WALTERS

# Ollie

CAIRN–JACK RUSSELL TERRIER MIX, 14

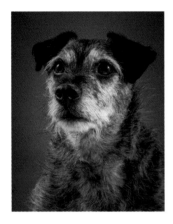

Ollie is my first dog—my heart dog. He is a cairn–Jack Russell terrier mix, and when I adopted him I knew absolutely nothing about terriers. What most of these people don't realize about these breeds is that there is a *lot* of dog packed into those small bodies, and all too often these dogs are returned to the shelter because they are more than the adoptive families bargained for. In 2012 I decided to start a terrier rescue, matching terriers with true terrier lovers and educating those who are unfamiliar with the breed. In the past two and a half years we have brought 232 dogs (and a few cats) into our rescue to start their lives over with new opportunities at finding forever families.

Ollie is estimated to be approximately fourteen years old but he is still as spunky as the day I brought him home. He loves to bark at birds, run zoomies, and play with his friends at day care. There is not a day that goes by that I am not thankful to have been chosen to be in Ollie's life.

TRACY McWHIRTER

# Sugar

CHINESE CRESTED, 16

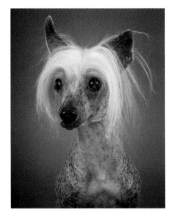

LIKES: warm jammies, sunshine, and giving hugs with her paws on your neck and nuzzling your face

DISLIKES: cold weather and rain

BACKGROUND: After her parents split up, Sugar was given up but eventually found her way to us. Not in the best health, we fed her several times a day to put weight on her and treated her skin for infections. She also has no teeth, common in her hairless breed. She has a wonderful "smile" that she greets everyone with. Over time, she slowly came out of her shell and revealed a sweet, smart, and happy little soul. She quickly showed us that she was patient, as she often played mom to foster puppies or kittens we have had in our home. She also knows how to fit in with any dog of any size . . . just a laid-back gal.

> *Old dogs, like old shoes, are comfortable.*
> *They might be a bit out of shape and a little*
> *worn around the edges, but they fit well.*
>
> —BONNIE WILCOX

AMANDA LAYTON-MALONE

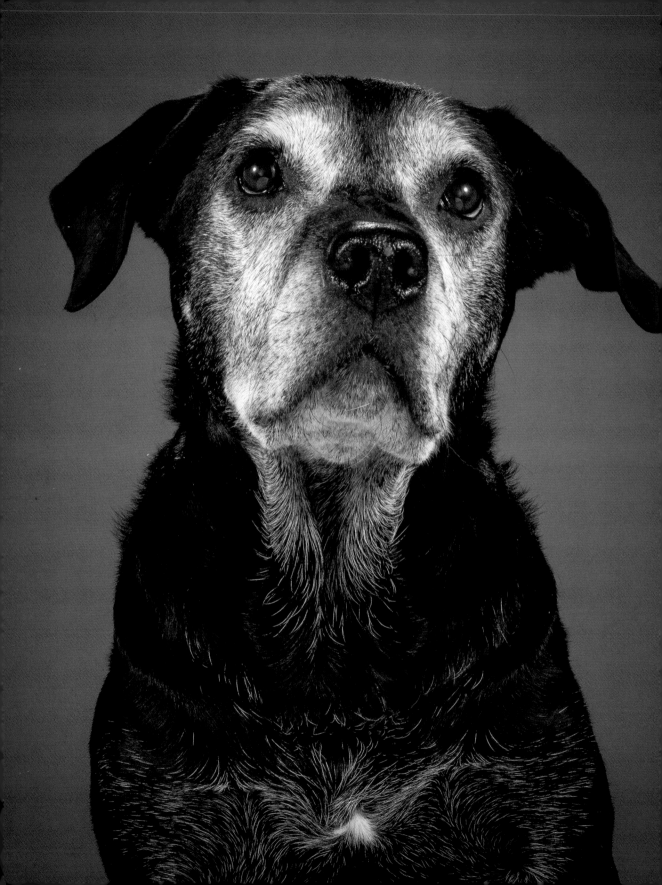

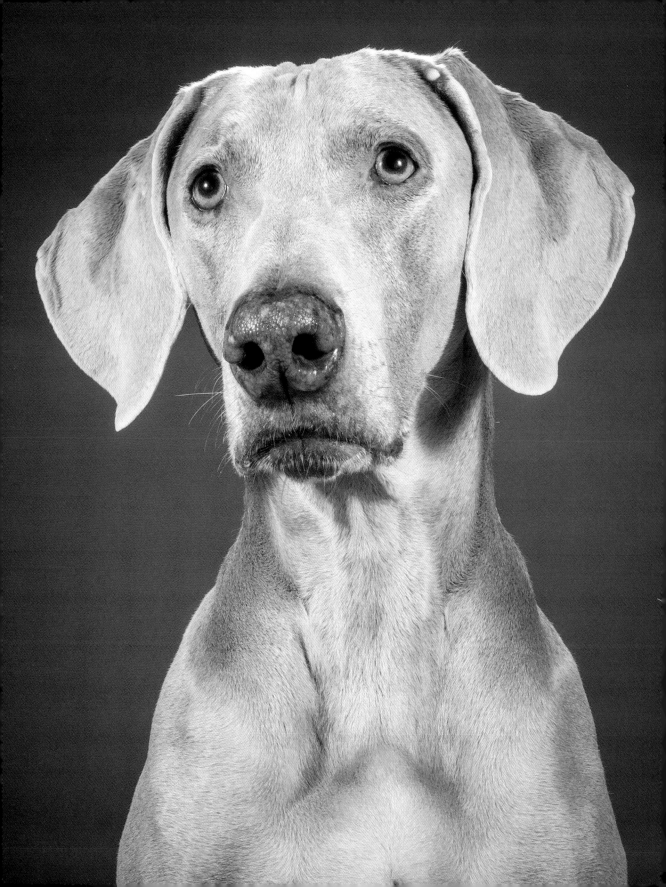

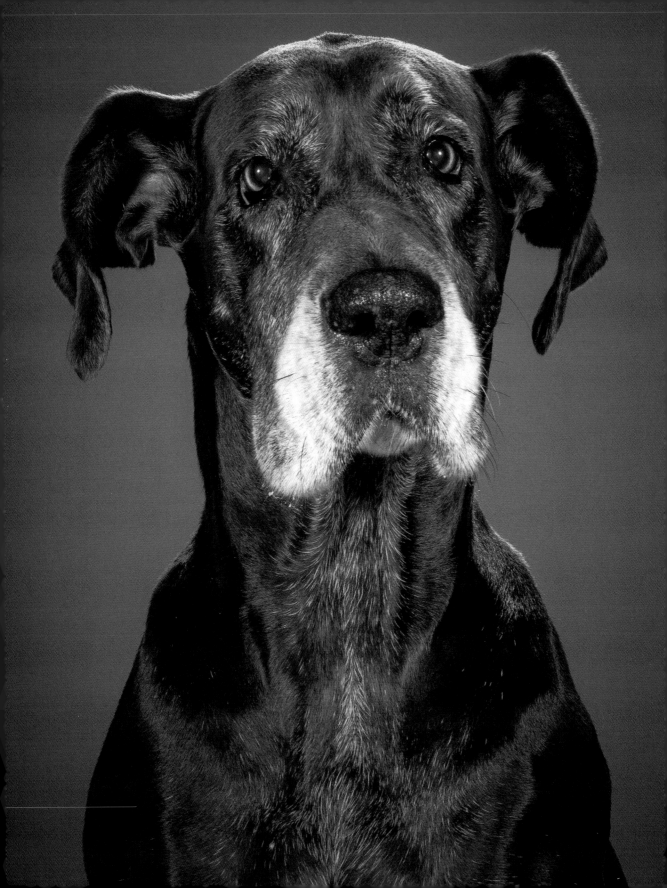

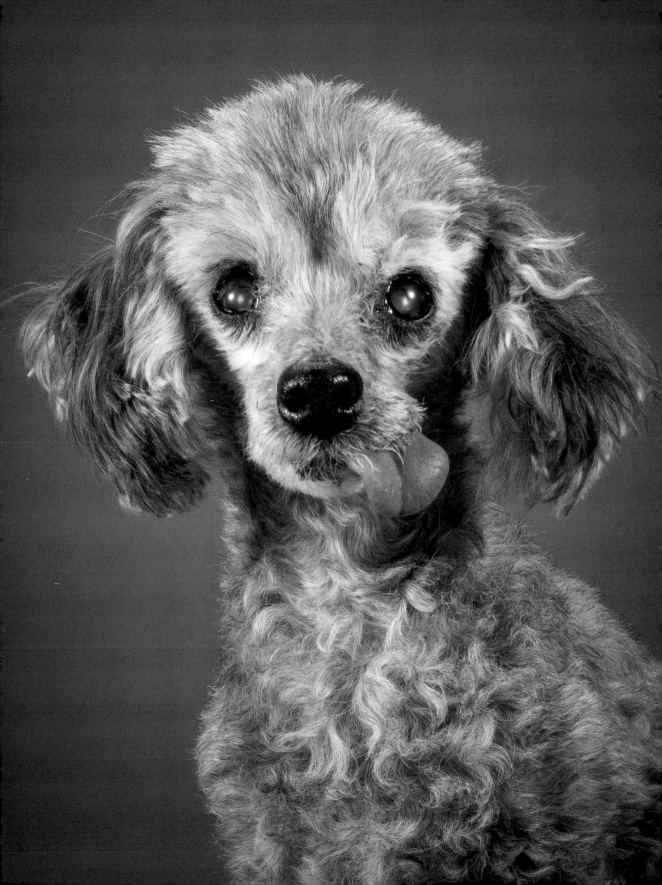

# Holly

BLACK LAB, 10

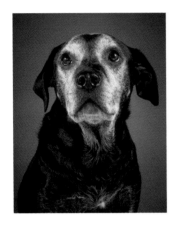

Holly is a lively ten-year-old black Lab. She has diabetes, but with a careful diet and ample exercise, she has it under control. Holly loves exploring the beach and splashing in the waves—and she's a great swimmer. At home, Holly loves to hunt her nemesis: the squirrel, but so far her lack of climbing ability has hampered her efforts. Holly has a calm demeanor, and if you're feeling down, she will snuggle with you and put her face against yours until you're happy again.

MICHELLE PINCH

# Atticus

WEIMARANER, 10

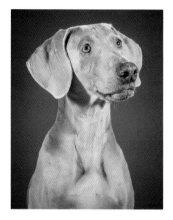

This is Atticus, a Weimaraner born on May 1, 2005. At three years old, he moved across the country with his family and two cats, camping along the way. To this day, he still loves camping.

In typical Weimaraner fashion, Atticus is always right there like a shadow. Our Velcro dog never leaves our side, or if he strays a few feet away, he never lets us out of his sight. He will settle in for a nice nap on the couch but will often look up to check on our location. Even in his old age, he has a sixth sense for when we leave a room and potentially "leave" him behind. This is especially prevalent at night, as he insists on sleeping in the bed, under the covers, and touching our legs at all times.

For Atticus, life revolves around being with his people. A close second is food, as he is always thinking with his stomach. This has him in the bad habit of begging for food, standing and resting his head on your lap while eating at the table, leaping around like a deer when it is his mealtime, and being obsessed with his rubber toy filled with peanut butter (while asking repeatedly to have it refilled by dropping the toy at your feet).

He is very protective of his family, except when walking at night and he sees his shadow, or some perceived shadow. Then, with his stubby tail between his legs, he starts dragging you home. Let me tell you, when a Weimaraner is on a mission, he is one powerful dog.

Despite this bundle of energy slowing down and growing new Weimaraner lumps on a regular basis, he still enthusiastically greets us at the end of each day with a fully wagging body and a huge doggy smile ear to ear.

HEATHER SCHOFIELD

# Isis

GREAT DANE, 9

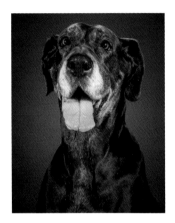

Isis was part of an SPCA seizure of more than twenty-two dogs, which included herself and her eleven surviving puppies. Shortly after that I became their foster mom. Isis weighed only fifty-six pounds and her whole system was shutting down. The SPCA told me to keep other people out of the area, since Isis was scared and protective of her puppies, but that didn't last long. She soon allowed anyone and everyone in without any worry.

I had to lay down with her in the kennel so that she would nurse her babies. I talked to her softly and gently and told her what a good job she was doing with her pups. I walked her when she was strong enough, which was something for a dog that had always been chained outside, and even inside.

Today, all her puppies have been adopted and most stay in touch. Isis is a healthy gal and still spry for being nine. Her sight is going, and some days she wakes up stiff, but she remains her kind Queen Isis. She has become my best friend over the last six years. She has helped me through losing my other two Danes, fostering other pups that have needed help and love, been there through my own medical issues, but mostly she loves me and I her. She is my shining example and my hero.

JENI MORRIS

# Grimm

TOY POODLE, 16

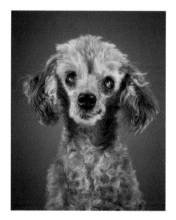

Grimm came into our lives three years ago at the tender age of thirteen. While his owner was on a trip, she sadly passed away, leaving Grimm with his owner's friend. Grimm's new family already had two big, young dogs that didn't know how to behave with a slower, older dog. They took him to the vet to prepare him for finding a suitable, loving forever home. It was discovered that Grimm would need all his teeth removed, had a heart murmur, a collapsed trachea, cataracts, and damage to his vocal cords, leaving him unable to bark. Grimm may have left the vet that day having lost all his teeth, but he never lost the charm and qualities that make him so unique and lovable. This is when we met Grimm. From the moment we heard his tiny squeak of a bark, and saw his tongue that refused to stay in his mouth no matter how hard Grimm tried, we fell in love. Grimm is now sixteen years old, still going strong, and is more lovable than ever. We hope to share all the wonderful qualities Grimm possesses that make us smile every day and that make Grimm one of the best old faithful pets around!

AMBER REHILL

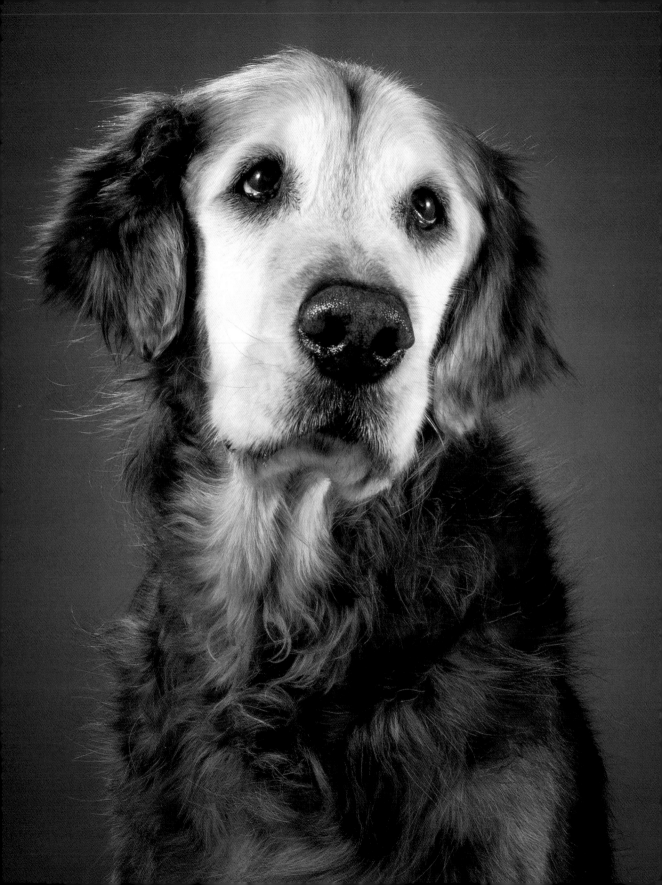

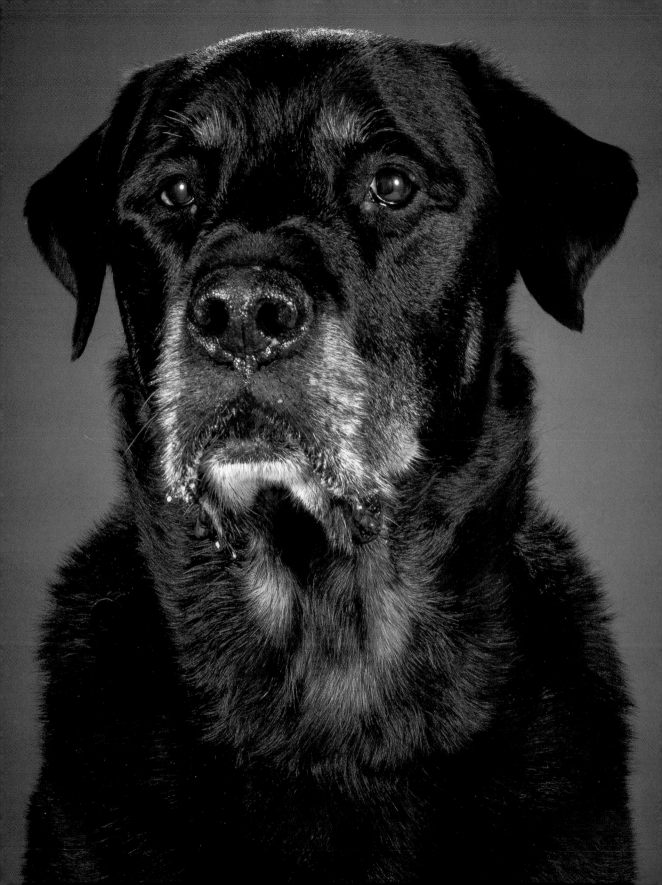

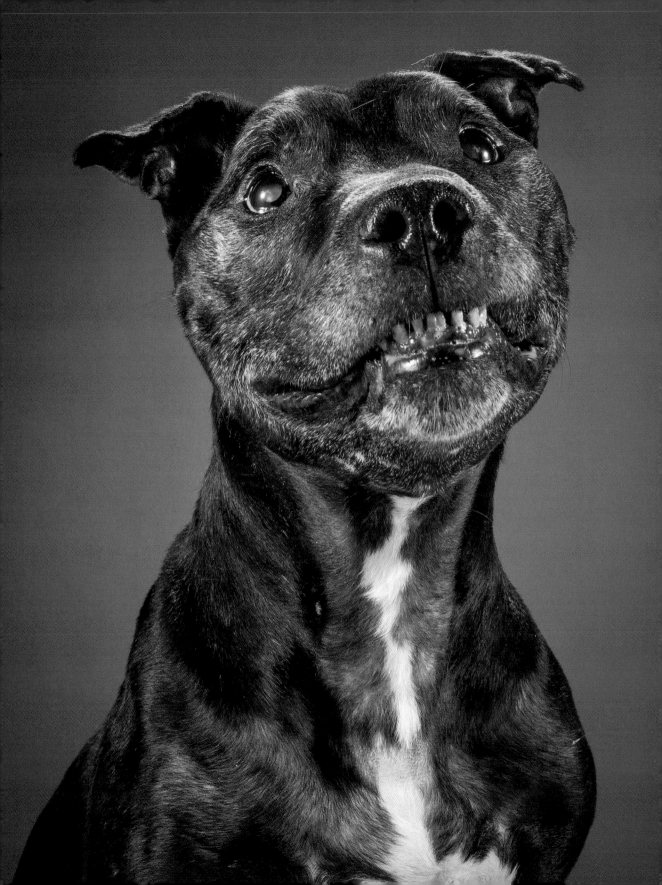

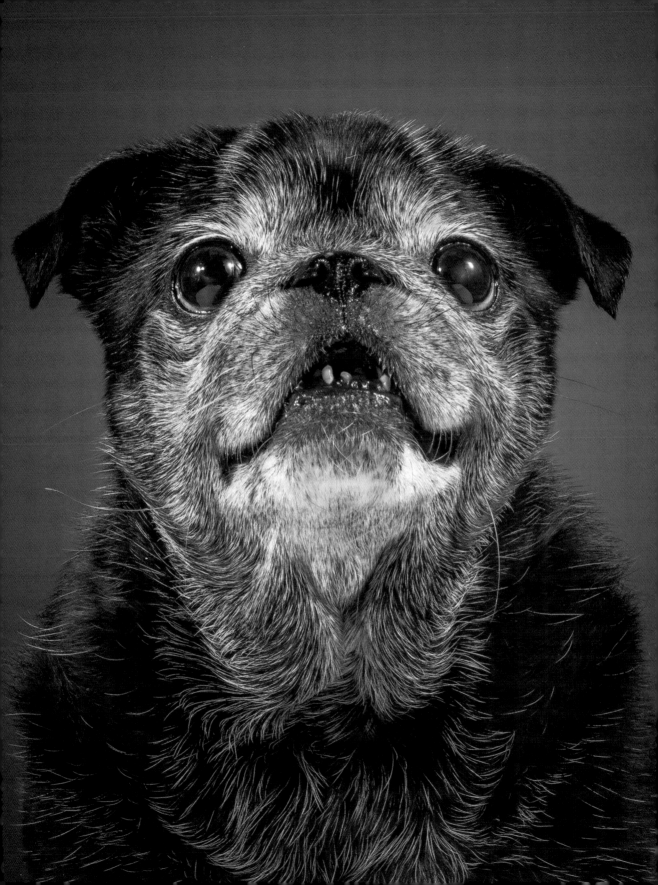

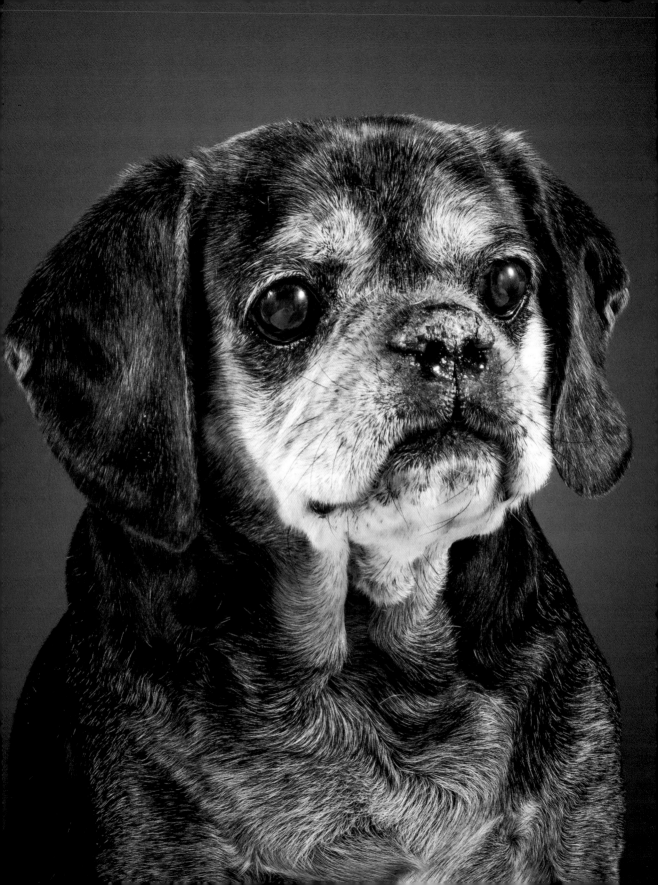

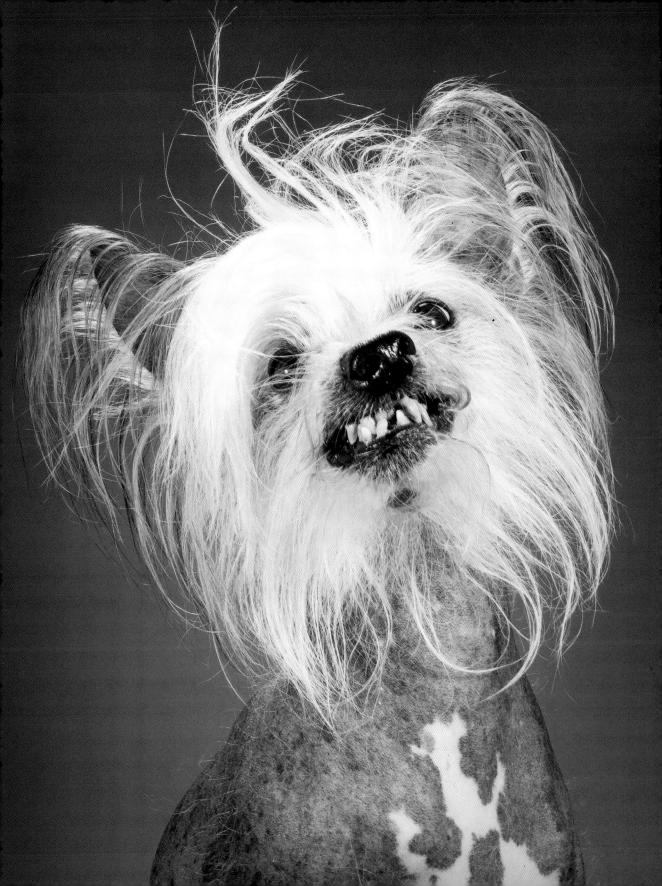

# Kingston

RED GOLDEN RETRIEVER, 16

Loyal, attentive, clever, beautiful, and humorous—Kingston is a proud and loving golden retriever.

Having had a career leading packs of sweaty mountain bikers through trails all around the maritime provinces, Kingston has retired to a life of swimming, walks in the woods, and almost always heading to work with his human. Since the day he was brought home, he has been teaching the world about love and compassion.

Having the ability to integrate a wonderful creature into my everyday life has been a true honor. I was lucky enough to meet him when he was about four weeks old. He bowled over the other little fur balls and made a beeline for me. That was it. He came to me at a time where I had just lost my very best friend, Keith, in a tragic airplane accident. I had to have a "K" name for him.

### A REAL TRICKSTER

This guy knows how to get the attention he seeks, and when he wants it. One cold day in November, a group of riders were stopping to take a break. It was a well-known fact that Kingston loved stealing gloves and helmets in an effort to keep the ride moving, but on this particular day, one of the ladies in our group forgot. Kingston quickly reminded her by grabbing her helmet and jumping into the lake—breaking through a thin icy crust and swimming to the middle, where he left the helmet and swam back to shore as proud as a pickle. Bobbing in the middle of the lake, the helmet was in no hurry to make its way back to us. Knowing that Kingston's breeding does not allow for me to throw away anything at all without his trying to bring it back, I amassed a pocketful of stones and began throwing them in the lake. My goal of leading Kingston to the helmet was a success, and he brought it back as proudly as he'd stolen it.

GRACEFUL RETIREMENT

After his retirement from mountain biking, he joined me whenever I would pick my grandmother up at the seniors' residence. There, he honed his skills in accepting love like no other dog. He would practice going around the circle from person to person, giving each the amount of time they needed in doggy snuggles. For many of the seniors, this was the most uplifting part of their week, and Kingston quickly memorized who those people were who needed his time most. He would never be selfish with his time.

Kingston just celebrated his sweet sixteen, and his party was well attended by many of his fans.

ADAM SHORE

# Brut

ROTTWEILER, 10

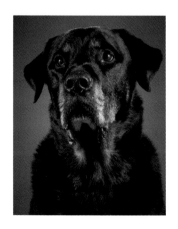

The quest for a new furry companion began when I approached the blue door that led to the dogs at our local animal shelter. The most atrocious noise was coming from the back kennels, where I found the most beautiful and maimed soul: a very underweight rottweiler who was left for dead in a barn along with his mother. Since his adoption date nine years ago, he has driven across Canada with me twice, stolen my heart, and saved my life. He's had a love for children since he was a puppy (he has a need to herd them as though he were their mother), enjoys walks on the beach with his four fur brothers, has taken part in community events such as food drives with local paramedics, and was even in the Christmas parade. The bond we have is like no other; he will always have a place in my heart, even after he leaves this world. His name is Brut, he is ten years old, and he is my hero!

SUEEAN MALONE

# Elmo

STAFFORDSHIRE BULL TERRIER, 15

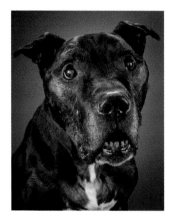

Elmo was born April 24, 2000. He is a Staffordshire bull terrier. He was eight weeks old when he was brought home to me, and I fell in love with him instantly. At fifteen years old he can still see, hear, and walk like a champ. He rarely moves or does anything except go to the washroom and eat. But he still props himself on the kitchen counter from time to time to check for food, like a young pup. Elmo was never a fetcher, a jogger, or even a play fighter. He was just always by my side whenever I needed him, my shadow, my best friend.

Most people feel bull terriers are a vicious breed, but Elmo has the kindest and gentlest heart I have ever known. He has a very calming demeanor to him that allows him to bond well with people and other animals. He is extremely independent and yet has a strong sense of when people need him most. He has an amazing personality and is super friendly. If pictures told stories, Elmo's photos would tell you that he has had a very happy and fulfilling long life.

It has been an honor and privilege having Elmo as my first pet and canine companion. Having Elmo in my life has taught me patience and what it is like to experience true unconditional love.

LINH DIEP

# Lulu

PUG, 11½

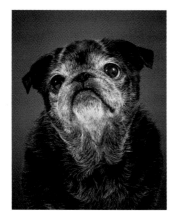

Lulu is an eleven-and-a-half-year-old pug—she is the perfect combination of crazy, cuddles, and toughness. You will always know when she is in the room, whether it be her grunts and snorts or her focused stare for her late-night second dinner. She makes me laugh every day, and some days I don't think she realizes she is all of eighteen pounds. Her file at the vet is as big as *War and Peace* but I can't imagine not being the one who has cared for her all these years. She's lived through cancer and fought a three-legged dog—resulting in a lost claw. If she were a big dog she'd probably be forced to wear a muzzle. She'll never let you easily clip her nails, clean her face, or sleep without her in the bed with you. But in my eyes, Lulu is a legend that snores like a drunken sailor and eats like a pig to slop . . . but I would never change this ridiculous amount of fun it's been raising my pug, Lulu.

TARA JAMES

# Eddie

PUG-SPANIEL MIX, 13

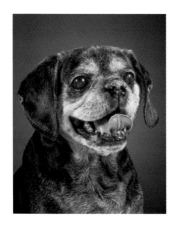

Our thirteen-year-old pug-spaniel cross, Eddie, was the best mistake ever. My daughter bought him from a puppy mill when she was twelve with her babysitting money as a surprise. As a single working mother, I had to sell him to another family, but we visited him every month, all of us crying (including Eddie) whenever we parted. It turned out that their daughter had asthma, and they called us one day saying they had to get rid of him. So we ended up taking him back. He grew up not ever knowing that he was a dog, as he was always treated like a family member.

He thrives on company, and always sits with his head on visitors' laps. As he approaches his senior years, he's developing lumps and bumps all over his body. His crusty nose is a conversation piece to anyone who does not know him. He has a terrible allergy to grass and sneezes nonstop on walks.

His eyesight and hearing are failing him, but his sense of smell is still amazing. Pull out a snack and suddenly his arthritis is not bothering him and he gallops down the hall like a colt. We have brainwashed him into thinking his glucosamine pills are treats.

Christmas and birthdays are his favorite times because he loves opening gifts. One year he crawled under the tree before we got up and found his gift (a ball) and opened it himself.

He does feel that he is entitled to certain privileges. He will sleep only in my daughter's bed, and under the covers. He will go downstairs to her room when he is tired, even if she is still upstairs, and bark for her to come down and lift him into her bed.

Everyone we know loves our Eddie, and hopefully we have him for a lot more years!

EVA FONTANA

# Colonel Sanders

CHINESE CRESTED, 11

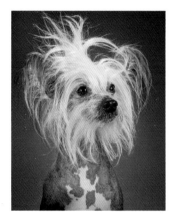

The colonel is an eleven-year-old Chinese crested that has been with me since he was three months old. He is a purebred show dog with best-in-show lineage dating back several generations to Asia.

We hitchhiked across Canada together, where he traveled in a pouch on my chest, and we snuck him into places under the guise of a baby. The colonel has canoed down the Klondike River and stood on glacial ice flows.

He is spry for an eleven-year-old, but a side effect of being hairless is shallow-rooted teeth. His are all slowly falling out and causing him discomfort, until I started making him all his own human-grade food. But when he sneezes, a tooth can just pop out.

The colonel lives the life, trotting around with my mom (his dog walker) during the day. I make him most of his clothes to stay warm. His signature look is a vintage neon Aztec-print razor-back tank top or fitted sweatshirt.

MORGAN MAVIS

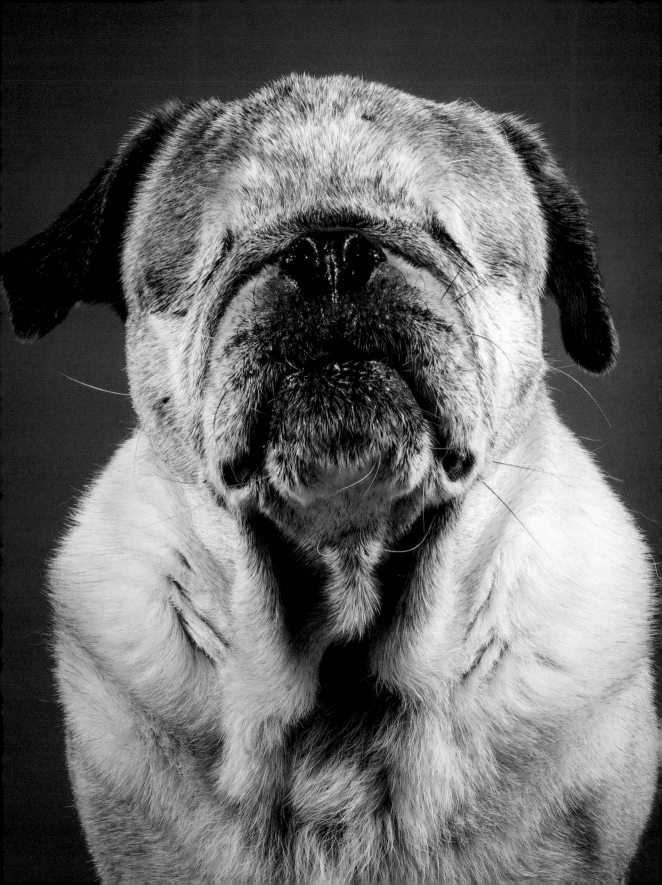

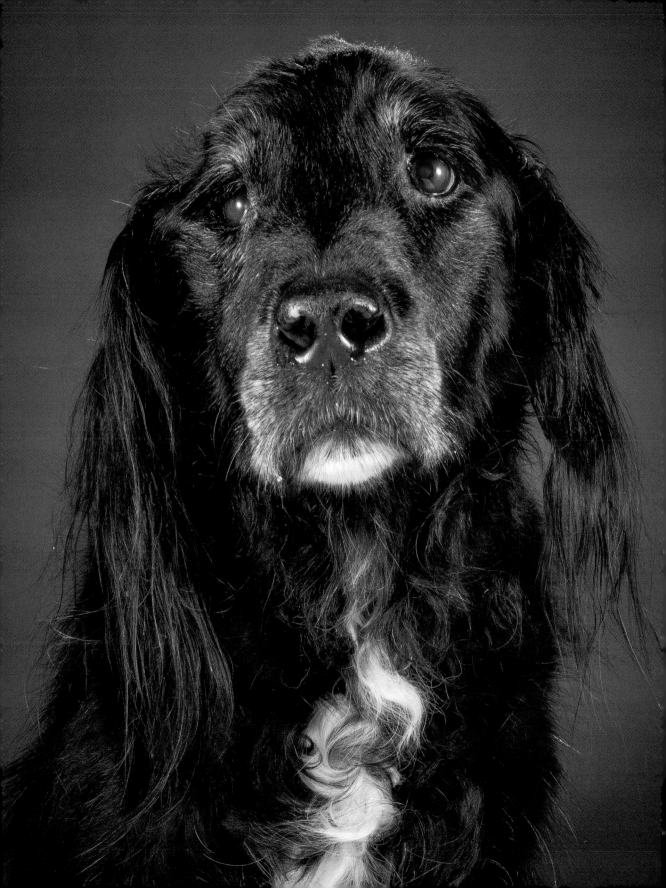

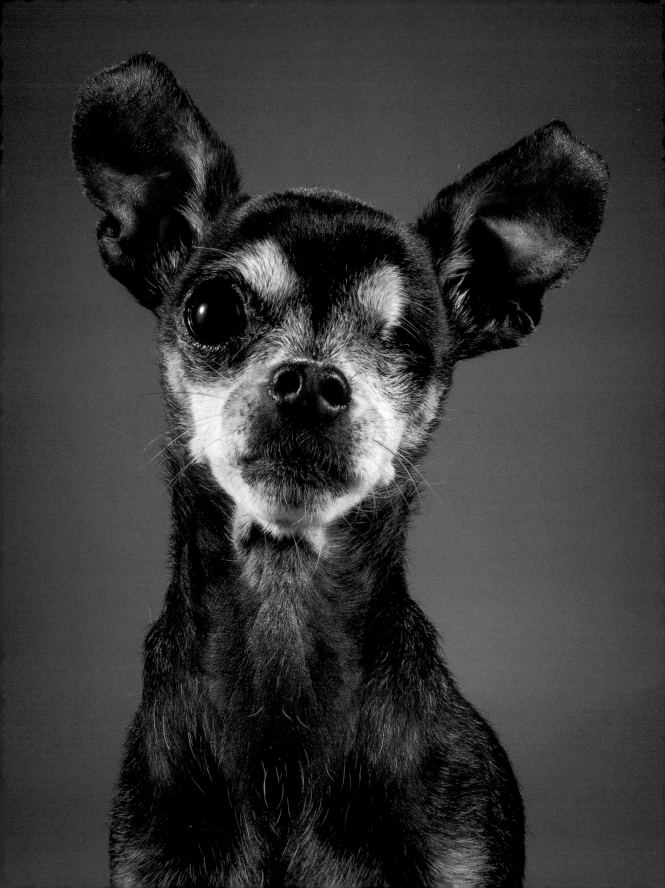

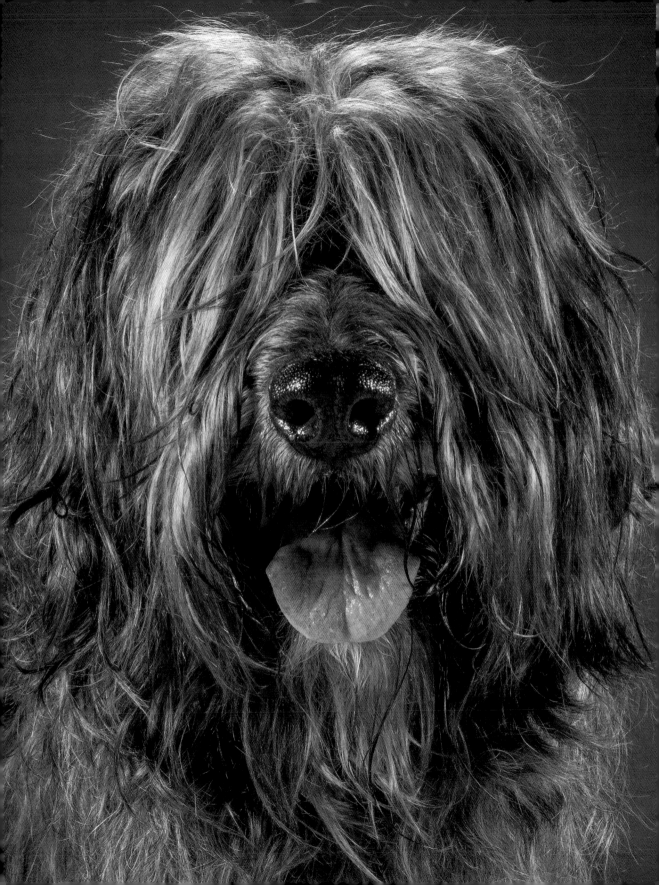

# Hazel

PUG, 16

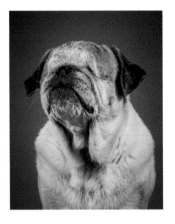

Hazel came to us after having lived in numerous puppy mills (she has *five* microchips from being rechipped every time she was sold to a new puppy mill).

We don't know her true age, but I adopted her in 2006 and the vet figured she was between six and eight. She was blind when we adopted her, but I had to have both of her eyes removed due to pain and lack of tear production.

But that didn't slow her down for a second. In fact, after each enucleation, her energy increased.

This is my girl. Loud, proud, and eyeless.

BLANCHE AXTON

# Blue

LAB MIX, 15

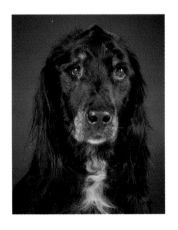

Blue has been a steadfast friend for more than fifteen years. She has been a great traveling companion and loves a good adventure.

Blue has a big, pure, open heart. In her youthful years, she would break up dog spats at the dog park by kissing them. She has always been a very social dog that loves visits and a good party. Her enthusiasm for life is infectious.

She has slowed down, but she still loves going for walks around the neighborhood. She's had the great wind down from the obsessive fetch days, and now all that focus goes into the quest for treats. And naps. Her favorite treat is seaweed.

These are her twilight days. She still has sweet, tender love in her. I am so blessed.

PAULA LUTHER

# Stella

CHIHUAHUA, 17

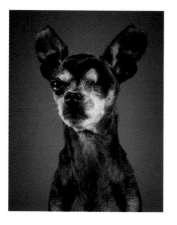

Stella lived with my late grandmother for ten years, and I recently inherited her.

She is very communicative. She makes noises, squeaks, squeals, and gestures to indicate her needs: A short quiet bark means, "Hey! Look at me!"; a paw wave means, "I need to go . . . NOW!"; a loud whine means, "Hey, lady, my food bowl is empty"; a whispery, long, persisting whine means, "I'm cold; wrap me up in my blanket like a burrito . . . please?"

Stella is a joy.

MELISSA JAMES

# Martin

WHEATEN TERRIER, 15

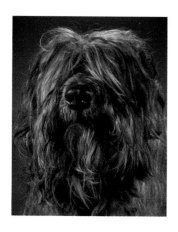

Martin has been our constant companion since he was just seven weeks old. He went absolutely everywhere with us and slept at the foot of our bed every night. He's now fifteen and feeling his age. He can't see very well, can't hear very much, and his back legs have almost given out on him. Climbing the stairs to our bedroom has become too difficult, so he now sleeps alone. On his occasional good days we help him climb the stairs in the evening and lift him onto the bed so he can be with us. Although he now spends most of his day sleeping rather than chasing balls, and he's unable to swim or go for long hikes, he's still Martin. He's still that very special dog that has spent his whole life making others smile.

DARREN JOHNER

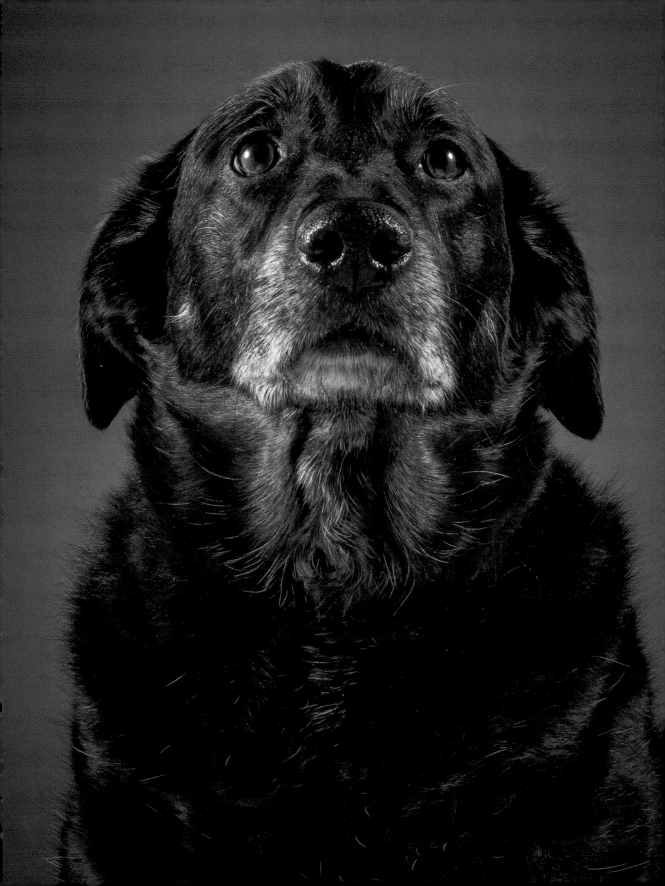

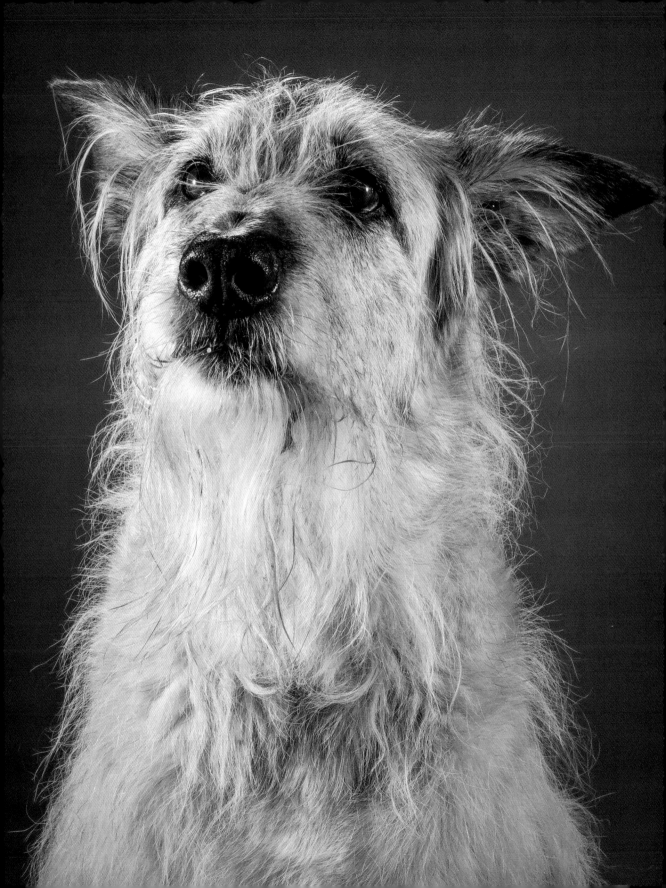

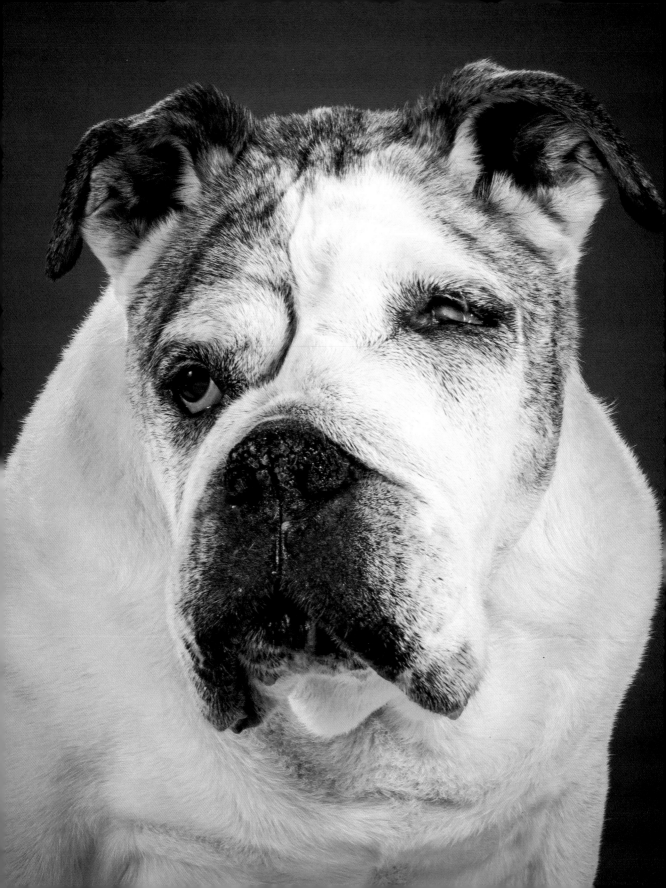

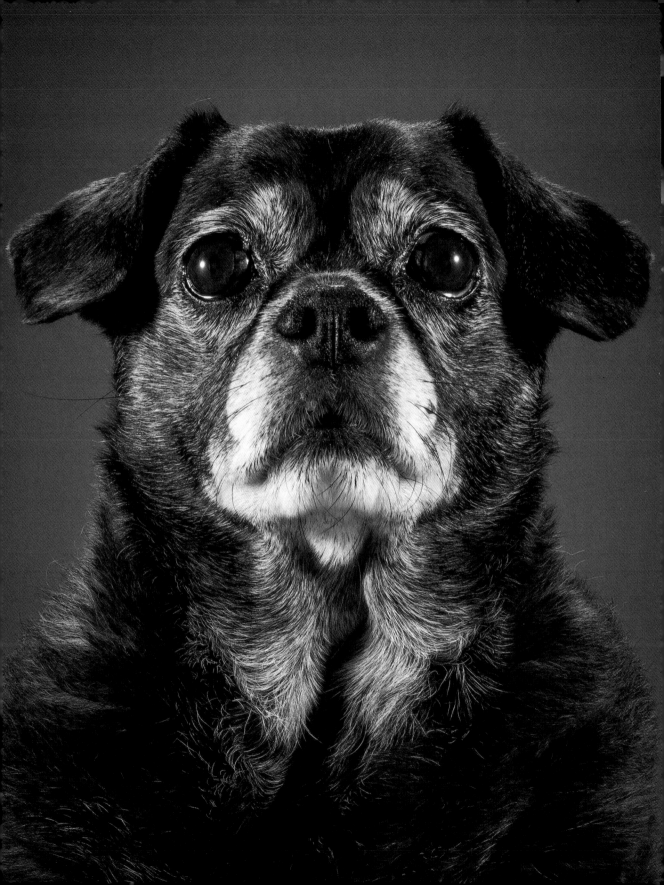

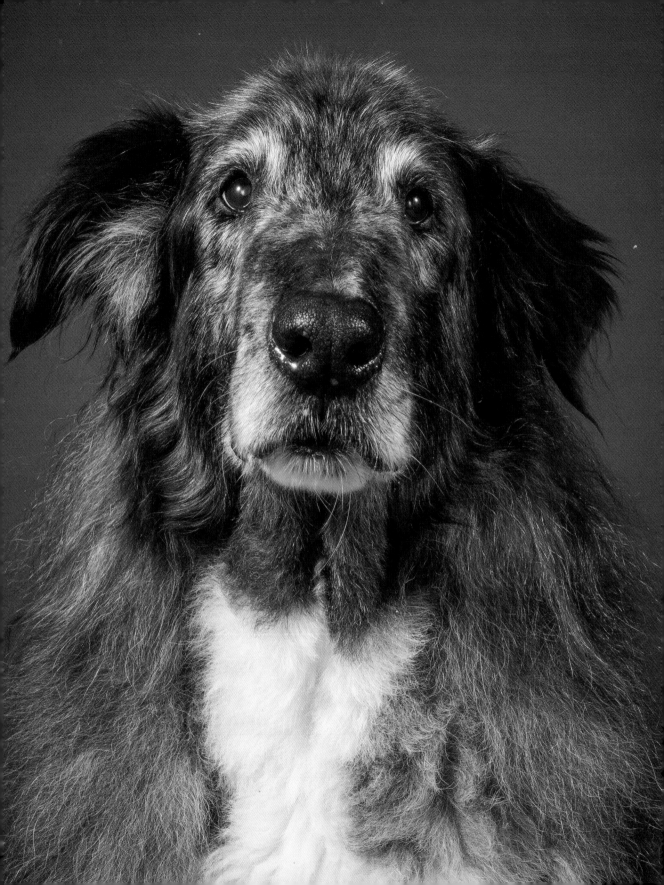

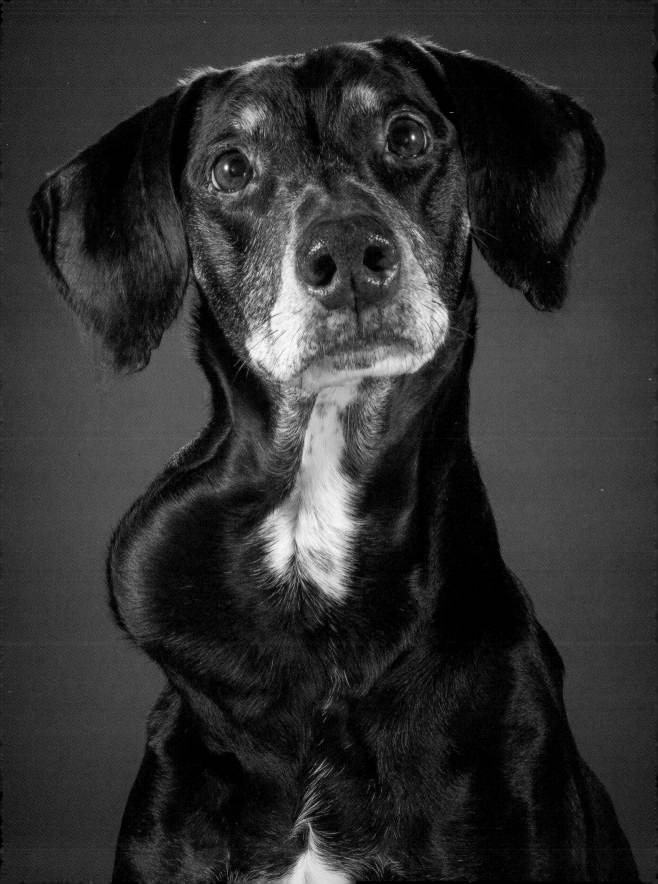

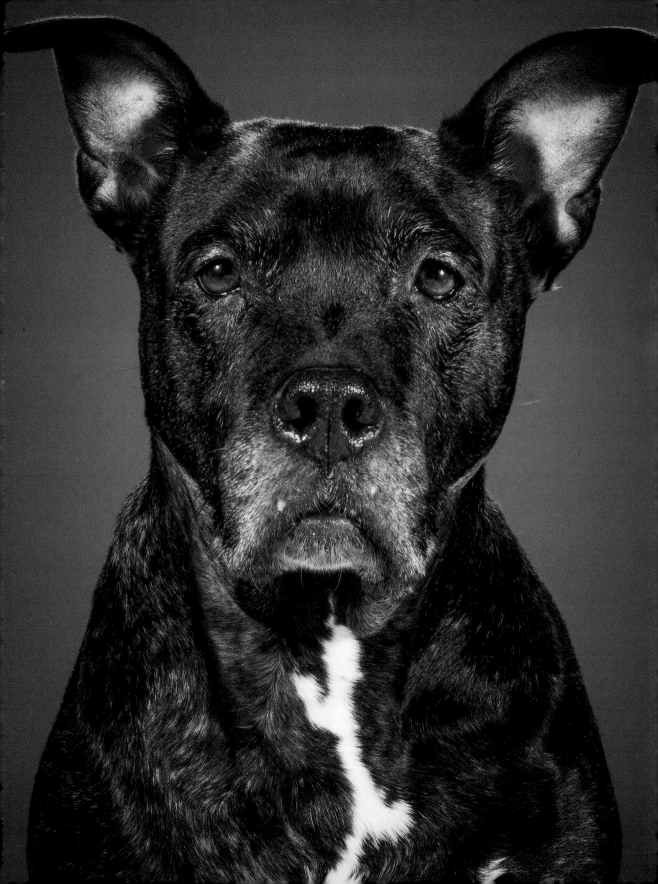

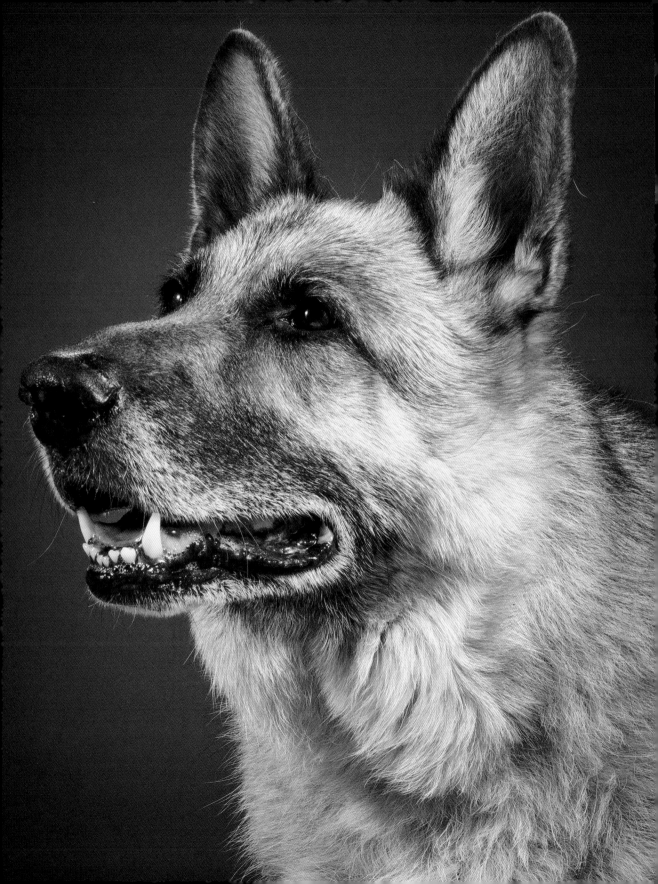

# Abby Evans

BLACK LAB, 14

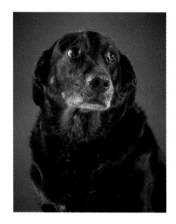

Abby came to us as a rescue dog. She was a pup from a litter of twelve, and her mom was only six months old. Abby is a shy dog with a passion for kittens and cats; she once took a kitten and kept it in a closet, where she took care of it. Abby has had four knee operations, so she is very calm and does not like too much excitement. In the off-leash dog park she is known as the "party police," because she barks at any dog that gets too excited. More than anything, she loves being in the car with the window open. When we arrive home, she may opt to stay in the car in case someone decides to take another drive.

Abby is loved by many and has brought much happiness to those who love her.

BARB HICKS

# Emmy

WOLFHOUND MIX, 14

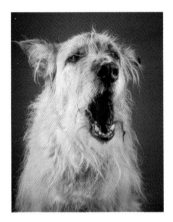

We were looking for a second dog and just happened to be at the Humane Society the day that Emmy was dropped off. She was petrified and all curled up and wouldn't let anyone near her. It was her second time being surrendered.

We inquired about her immediately and learned that due to her extreme anxiety, they likely weren't going to have her adopted. Despite our pleas to let her come home with us, they were considering euthanizing her. We called to check in daily, and then one Saturday they called us and let us know that she was going up for adoption. We ran to the car and the rest is history.

Emmy is a big chicken with a giant bark. Strangers' "Oh what a beautiful dog!" are, more often than not, met with a loud, belligerent bark. But anyone who comes in the house is greeted warmly and is an instant friend. Emmy has been a true friend to all our dogs (fosters too) and cats, a sweetheart to our children, and an amazing companion to us.

It's been almost fourteen years now, and we have always felt incredibly fortunate to have been in the Humane Society that afternoon.

CHRIS COBAIN

# Mance

OLD ENGLISH BULLDOG, 13

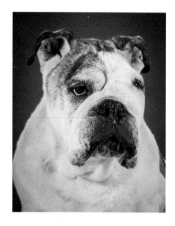

Mance was born in November 2001 in Tennessee, the son of a dame named Molly and a future movie star named Tank. Though he had the looks and talent for Hollywood, Mance instead devoted his life to being the best friend to two humans named Brian and Michelle and a silver cat named Syeeda. He was tolerated by two other cats, Pannonica and Doyle, who liked to stand between him and his toys or make him wait his turn at the water dish. Mance, like the bluesman for whom he was named, was raised in Texas, where he first learned that the key to happiness is climbing into bed for cuddles every morning. Actually, Mance was happy to cuddle anytime, even if he had to dig under the covers of a carefully made bed in the middle of the afternoon or give up his favorite spot on his dog bed to a pushy cat.

By the time Mance moved to Toronto in 2009, he had learned to sit, stay, lie down, crawl, bow, speak, roll over, and sneeze on command, and he eagerly performed these tricks, sometimes all at once, to impress friends and family. By the end of 2009, he had also learned that he didn't like to get his feet wet or wear a winter coat, and that peeing in the nearest drainage grate was the fastest way to get back to the warmth inside. Mance was also an amateur physicist, nudging tables to see how far he could tip them without falling over, and a comedian, playfully avoiding eye contact when it was time to take a b-a-t-h. When he laughed or wagged his nub of a tail, his whole body would vibrate and wiggle. Mance was also an empath, not like a Betazoid, but like a best friend who knows just when to lie at your feet, bring you slobbery stuffed toys, or rest his head on your knee. Despite his best efforts, Mance never perfected his mind control of humans, and he knew better than to try to control the cats. However, his steady stare with those big brown

eyes often tricked weak-willed humans into parting with their last bite of bacon or meat loaf.

In his final year, Mance got a form of bone cancer in his nose that might have hurt his vanity if strangers ever stopped telling him how cute he was, but they didn't. By then, he had outlived his cat friend and frenemies, and he was solely responsible for making sure the two humans were happy and well loved, which he did like a champ. They said good-bye to Mance in November 2014 in their home with the help of their vet, Paula, who had made sure he was comfortable that last year and in the end. Brian and Michelle still miss him every day, and even though they have not yet cleaned his slobber off all the windowsills and doorjambs in their home, they no longer cry every time they are reminded of him either.

MICHELLE DION

# Weezee

PUG-BEAGLE MIX 11

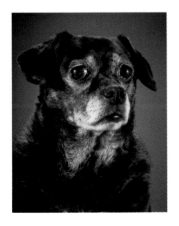

Weezee came to me via an adopt-a-thon held at a local pet store in the summer of 2009.

She had the happiest personality and the waggiest tail. I fell in love with her right away. I met her and walked her home all within an hour!

She is loyal to me and tends to follow me around no matter where I go. She even sits next to the tub when I take a shower.

She is happiest around people and has been able to learn new tricks even at her age. She is totally food-obsessed and is the most obedient when there is a treat in my hand.

I am looking forward to many more years of her sweet and sunny company.

MICHELLE SMITH

# Kobi

BLUE MERLE COLLIE MIX, 15

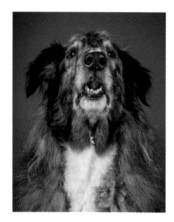

Kobi is a fifteen-year-old blue merle collie mix, and we've shared an incredible journey. He had been adopted from a pet store only to end up at the SPCA one week later. I saw him and fell in love, but sadly he was already adopted. A week later I found out the adopter never came back for him, and so at four months old, he adopted me.

Kobi was the perfect pup, smart and loving with everyone. He is a versatile boy. He would spend hours in a small boat and when a fish was caught, he had to inspect it and then give it a kiss before being released. His sports career started as an agility dog reaching the masters level and attending several regional competitions. He is very versatile and loves to try new things. But when we tried dog dock diving, I soon found there was one thing he wasn't willing to do. Being in actual water is not his idea of fun. We never did make it past one jump.

As Kobi got older and could no longer compete in agility we decided freestyle dancing might be fun. Kobi can dance and I'm still working on it. Last year at the age of fourteen he got five freestyle titles and two Trick Dog titles. Other competitors tell me that he is inspirational and he has given them hope that their aging dogs might still want to have fun as they get older.

When my other dog was ill and had special needs for four years, Kobi had to take the backseat. He did it with grace, patience, and understanding. Never once was he resentful and always stayed happy (his tail wag never stops).

Last year was a rough year for Kobi. He had an adrenal gland removed and then a few months later a parathyroid gland. But he bounced back from major surgery and continues to amaze me and everyone around him. He still may have one more dance in him.

He's my confidant, my friend, my teammate, my smile every day. Our journey together has taught me so much. I'm a better pet owner and person from having him in my life. It truly was meant to be.

CARRIE GAUTHIER

# Starr

GERMAN POINTER MIX, 14

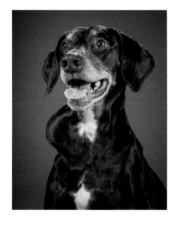

Anyone who meets Starr is astonished to learn her real age as she has such a zest for life.

Starr still enjoys trekking around a lake near where we live, playing keep-away in the yard, and reveling in bountiful naps. Starr has had her ups and downs with her health, including scaring us with geriatric vestibular disease. As the symptoms are similar to that of a stroke, it was quite frightful, but she is always proving her hearty farm stock is built to fully bounce back.

The lumps covering her torso and neck have been monitored and consistently aspirated over the years, thankfully each time resulting in benign fat deposits. These lumps started around age eight, slowly growing and multiplying over the years. They cause her no discomfort and the stress of surgery would be for our selfish benefit, not hers. She has the ability to make those that encounter her quickly move past what we see on the outside to focus on what lies beneath.

She is a gentle soul that will have a smile spread across your face within moments of meeting her. She has the ability to put those around her in a happy mood.

When she ran up to me fourteen years ago for the first time, I had no idea about the journeys we would take, or the level of companionship and joy she would fill my life with.

TANYA ROSENBROCK

# Charlie

PIT BULL–BOXER MIX, 12

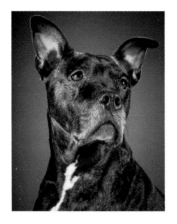

I am a fellow photographer and have had my trusty dog assistant for six years now. Charlie is a twelve-year-old pit bull–boxer cross who still bounces like a puppy when her arthritis is not acting up.

Life wasn't always cuddles and pets for Charlie. Her life began in a kennel locked in a cage for three years before being rescued. Unfortunately her second home wasn't a fit either. It looked like poor Charlie, still just five years old, would enjoy shelter life at best.

This is when I met Charlie, and her life changed forever. With patience, love, and a little bit of discipline, Charlie's rough edges have all but disappeared. With that wide-eyed love and devotion that only an adult rescue dog has, Charlie has been a rock for me in return.

As I go through the ups and downs of life as a young photographer, Charlie has been by my side. She is my best friend and therapist. For the past three years I have been transitioning genders and she has been my constant companion and support. The amount of love dogs give is truly amazing, and Charlie is nothing short of special. She is a black and golden-brown brindle dog and now has gray on her muzzle and eyebrows. Charlie's somber gaze (now with a few grays sneaking in at the corners) as she sits on the feet of a model getting her hair done gives everyone a sense of calm before a shoot. Just as when the last shot snaps, Charlie is eager to photo-bomb for some candid laughs and kisses.

Life is an endless flow of new friends for sweet Charlie girl. She is happy in her forever home.

RAY McEACHERN

# Caya von Brolan Clark, aka the Pupper

GERMAN SHEPHERD, 10

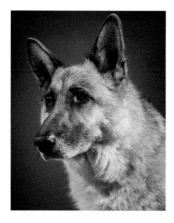

Our dog Caya is a sweet and gentle soul, smart and stubborn, and at her best has a devilish streak that always makes us laugh. She is aloof but doesn't have a mean bone in her body. She is a friend to all dogs, an enemy of all birds, and loves water so much that we think she may be part fish.

Caya is a wonderful companion to our other dog, Triton. He had a rough start to his life and doesn't get along with other dogs. Caya is his only friend. Without her he would be lost. Sometimes he takes advantage of her gentle demeanor, but she can always outwit him to get whatever she wants.

Caya came to us when she was seven weeks old. She was the first of her litter to escape her whelping box and go on an adventure. There has never been a situation that Caya could not handle with ease and a loving attitude. On a walk, Caya will only be satisfied with carrying the largest tree branch she can carry down the middle of the path.

We have shared many adventures together. We love Caya with all our hearts.

SEAN CLARK

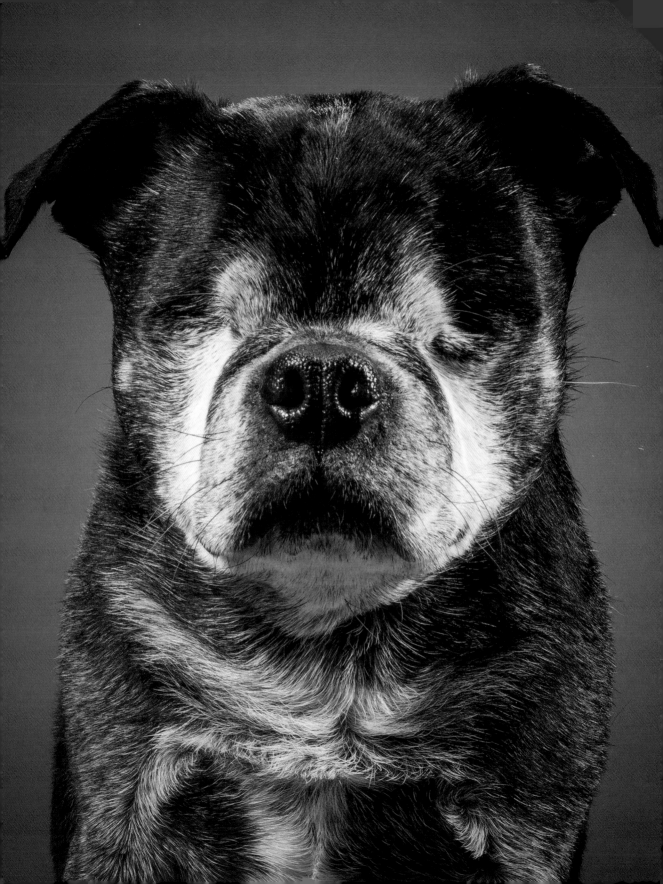

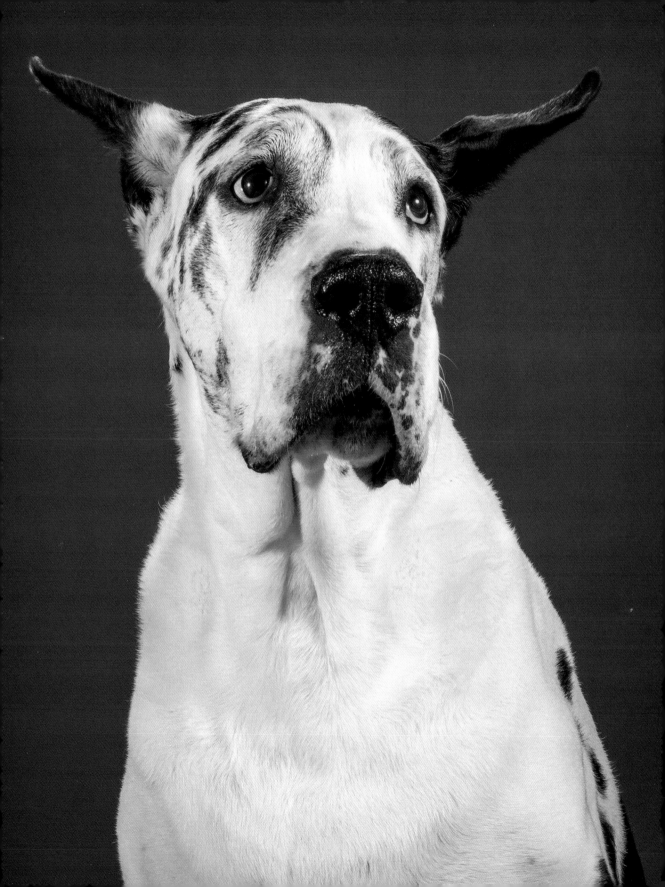

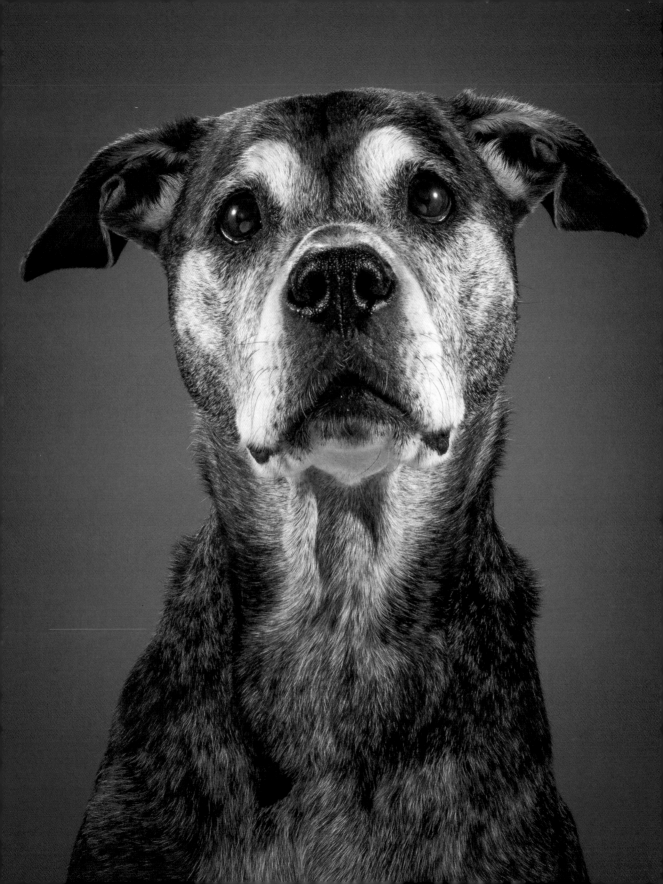

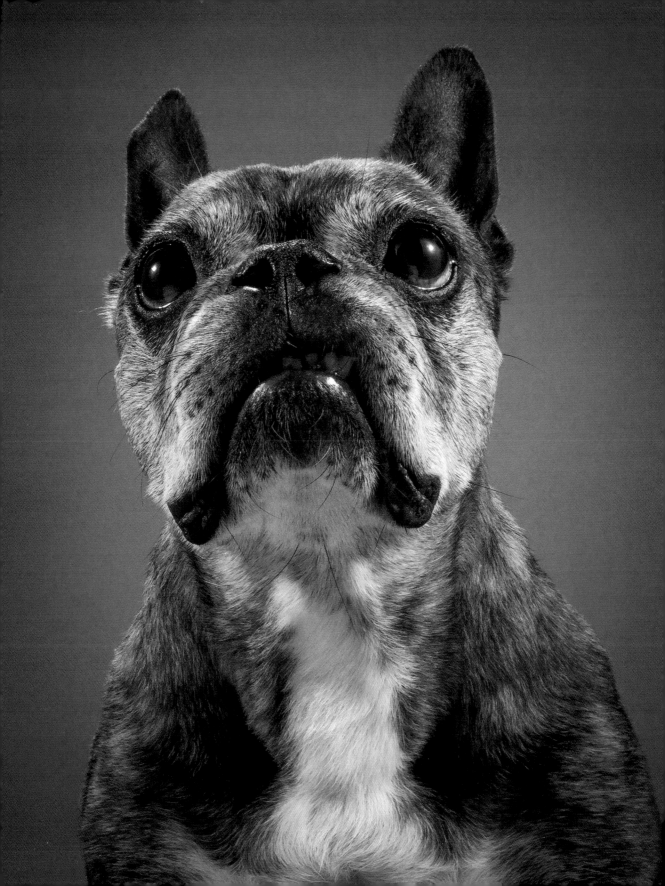

# Bugzy

BOSTON TERRIER–PUG MIX, 13

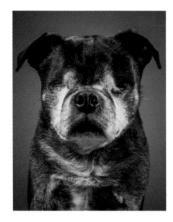

Bugzy (or Bugz, as his friends like to call him) is a thirteen-year-old half Boston terrier, half pug: a bug.

Bugz lost both of his eyes due to an infected cyst. He has shown great strength and adapted quickly to this disability. Being blind does not stop Bugz from being curious; in fact, he can sniff out a tree or lamppost quicker than most. He's also very affectionate and loving.

Bugz likes to go on walks (in between sniffing), the occasional game of tug, cuddling, and, best of all, eating.

He still walks with a swagger, with his head held high, and maneuvers curbs and stairs like a pro.

Bugzy is a very faithful friend and will always hold a special place in our hearts.

LYNN HUGUET

# Sega Kowalski

GREAT DANE, 10

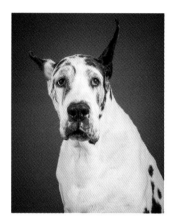

Sweet Sega came into our lives when she was already quite an old girl. We had just lost a Dane who was an amazing twelve years old, and the whole family was grieving her passing, but none more than our male Dane, Maddox. Maddox was despondent and refusing to eat; he needed a companion. After meeting a number of young Danes, none seemed like a fit. We learned of one girl who needed a home, but she was eight years old—already elderly for a Great Dane. But when Sega came around the corner it was like we'd known her forever; she walked straight up to our then five-year-old son and gave him a giant lick on the face. It was like she was saying, "Hey, guys! What took you so long?" Sega came home with us that day, and Maddox ate dinner that evening, for the first time in a week.

Our sweet Sega is now ten years old. She is beautiful inside and out. A quiet warmth and dignity surrounds her, and she offers us more love and affection than we could ever hope to reciprocate. We are grateful for every day we have with her.

JESSICA KOWALSKI

# Bella

PIT BULL TERRIER MIX, 12

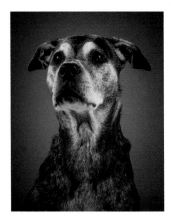

We do not know anything about Bella's background. She was found tied to the fence of a shelter one morning. It was the middle of winter, so she was very lucky to have survived. For a few days, she sat in her kennel confused and scared. The woman who rescued her said that, according to the shelter staff, Bella couldn't stop shaking and wouldn't eat. Realizing the chances of a senior dog being adopted were minimal and that she would likely be euthanized, a rescuer took her from the shelter and brought her to Nova Scotia. She spent several months in a foster home with a wonderful young couple and their dog.

My partner and I already owned a boxer and had recently lost a ten-month-old puppy to kidney disease. We were devastated and had no plans to adopt another dog. However, after reading Bella's bio (and a subsequent post indicating that they hadn't had any interest in her because of her age), I was heartbroken. I convinced my partner that we should meet Bella, and the rest is history. She officially joined our family in June 2013.

Given her background, it took her several months to adjust. However, she is now a happy-go-lucky dog. She is an expert at fetch and absolutely loves, loves, loves the water. She will swim for days, if you would let her. She also loves to come hiking with her family and will even chase along beside the four-wheeler. She is one of the most loving and loyal dogs that I have ever met, and our vet is continuously impressed with how agile and playful this senior baby is. Our boxer, Brody, accepted her immediately, and they are now closely bonded. Bella also attends a local doggy day care, and we were recently informed that she has a boyfriend there.

TARA AND ANGELA MURPHY

# Spud

FRENCH BULLDOG, 12

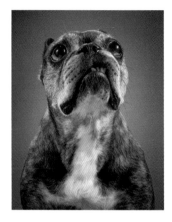

We think Spud was about six years old when we got him, although he came from a puppy mill, so we don't know for sure. He's probably around twelve now. We suspect he spent the first four or five years of his years in a cage, and was definitely neglected and very badly cared for. He has a hernia and a heart condition and he had several rotten teeth up until a few months ago, when they both fell out in the same week.

When we got him, he really did look like a spud: he was fat and round and had the brindle color. He still loves to run in the park with his young brother, Sherman, and funnily enough seems younger than ever most days, even if he is starting to look like Santa Claus. I first got him as a companion dog for my older dog, but after he passed, Spud didn't do well alone. Sherman was a blessing, and gave Spud a new lease on life.

He's a very funny guy, dumb as a bag of hammers but with a heart the size of Florida and he has those cartoon puppy eyes that just melt your heart.

Spud has a lovely disposition and he's never grumpy. Now that he's older he's become very vocal, and I think he's trying to tell his story.

DANIELLE COHEN

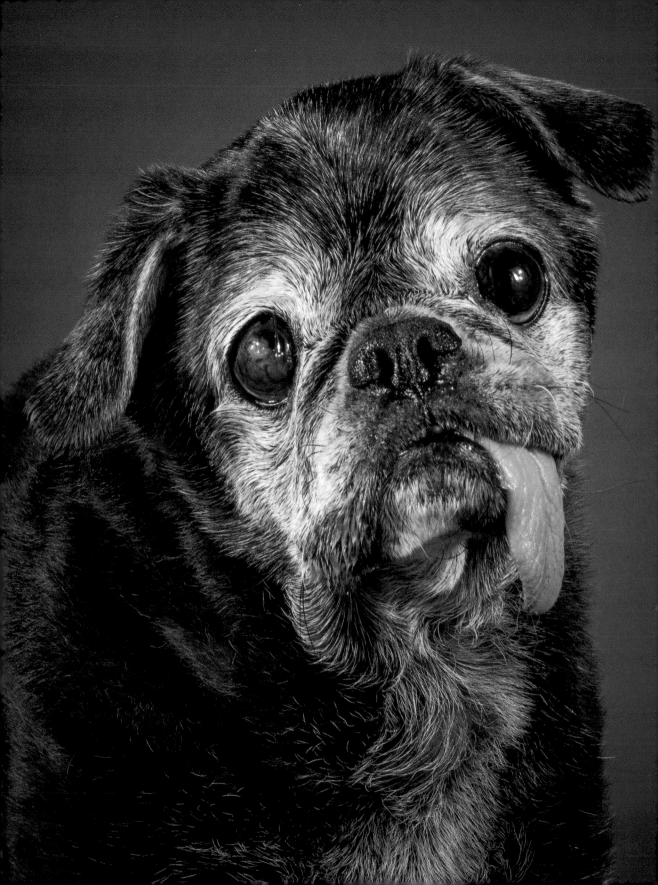

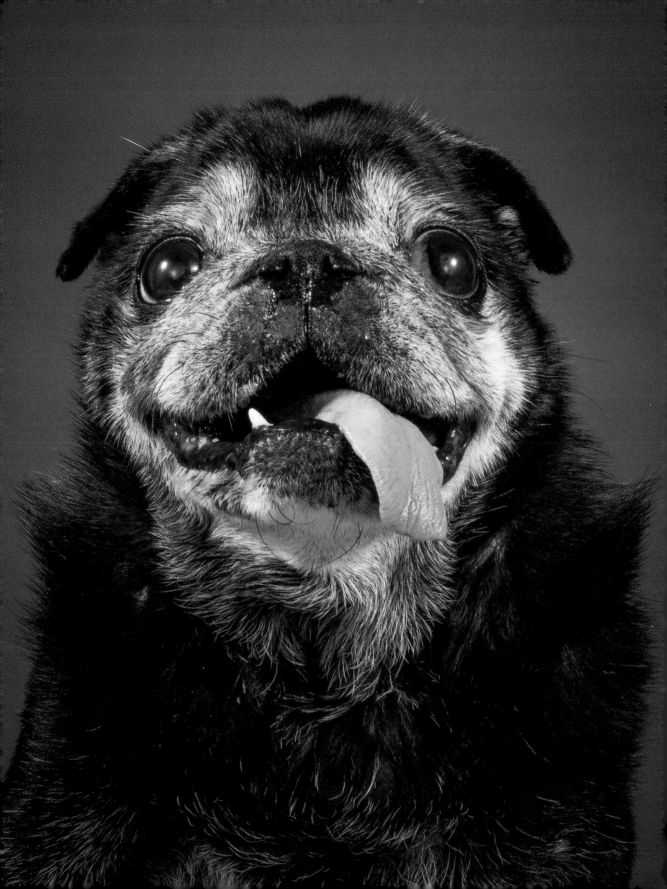

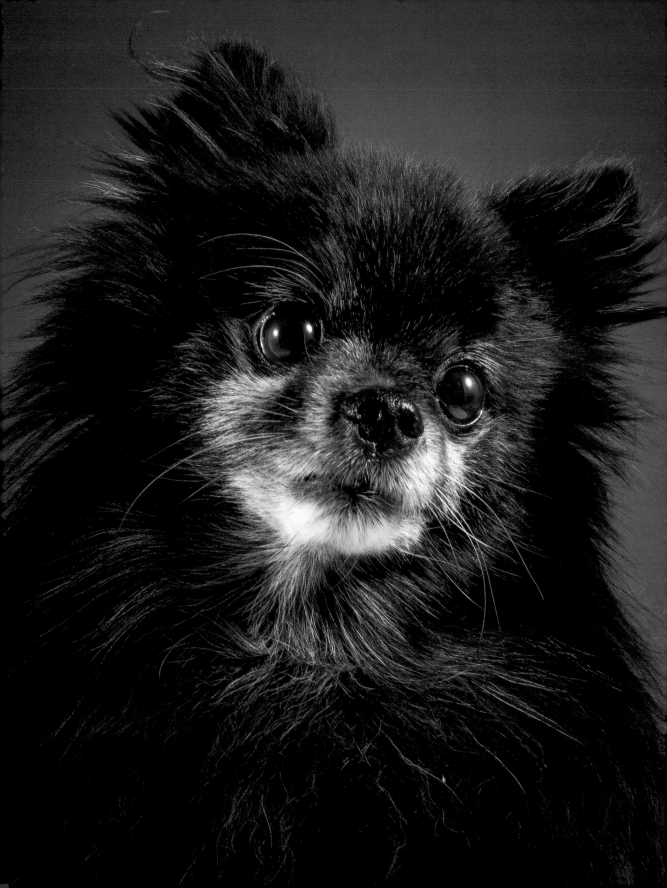

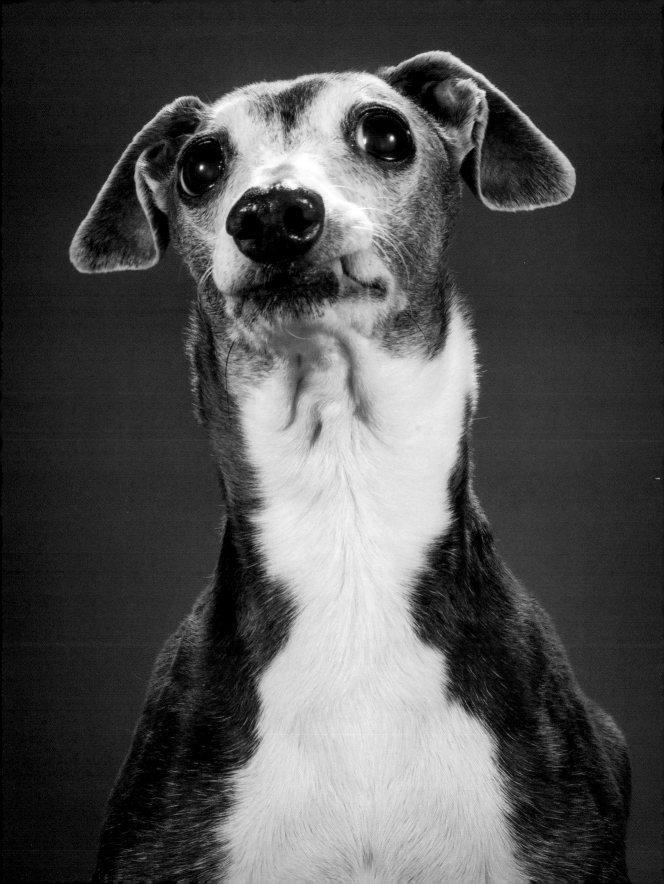

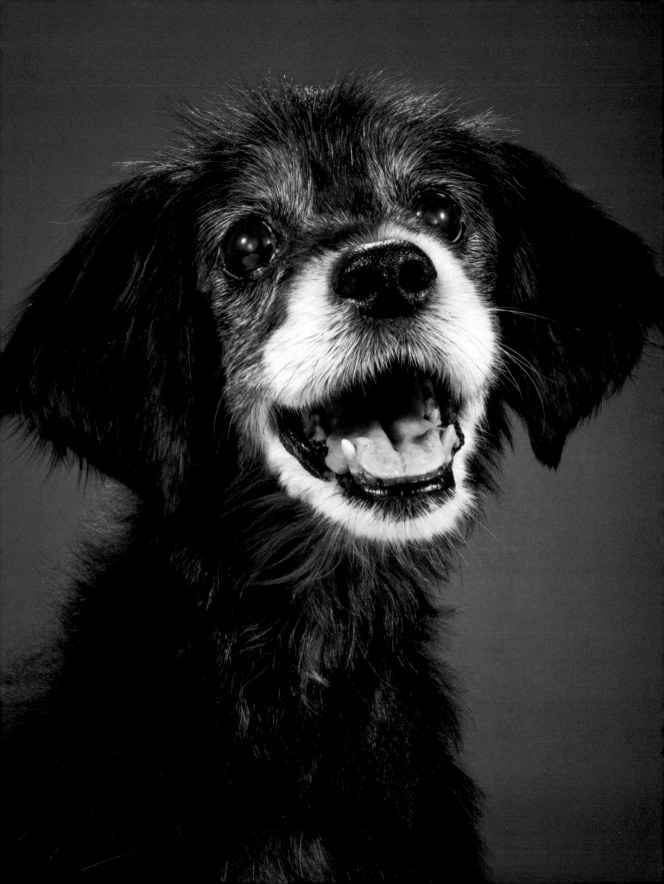

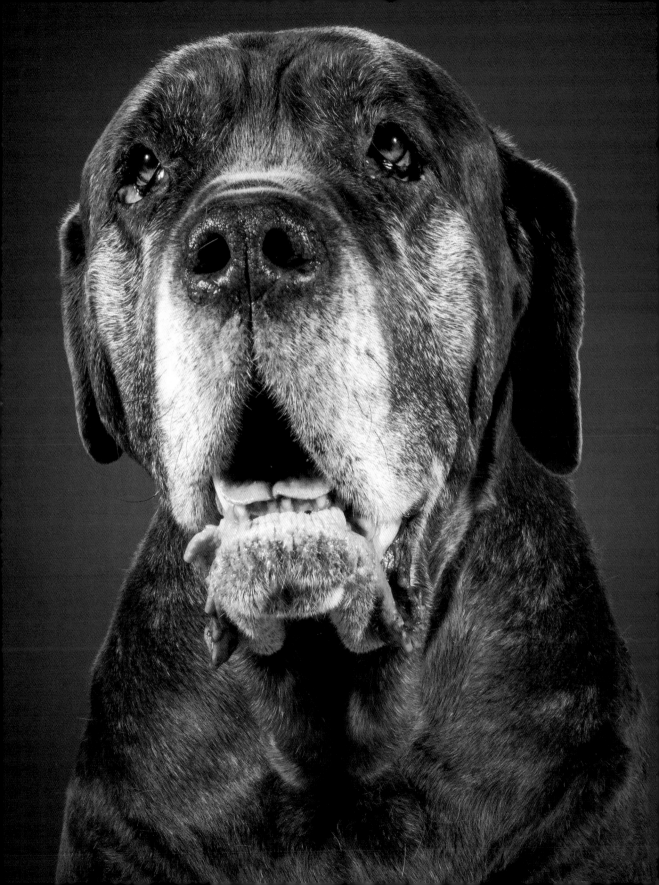

# Benjamin

PUG, 13

SANDY BOOTH

# Beulah

PUG, 16

LESLEY AND DEREK ANDERSON

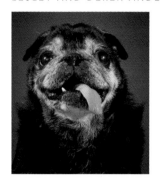

# Fang

POMERANIAN, 10

CHERYL LEANNE

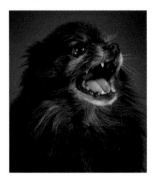

# Gigi

ITALIAN GREYHOUND, 13

SEAN HOPTON

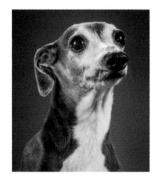

# Piper

SPANIEL CROSS, 16

KELLY BURT

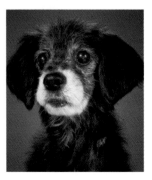

# Bubba

NEAPOLITAN MASTIFF, 10

FRANK FLETCHER

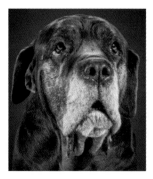

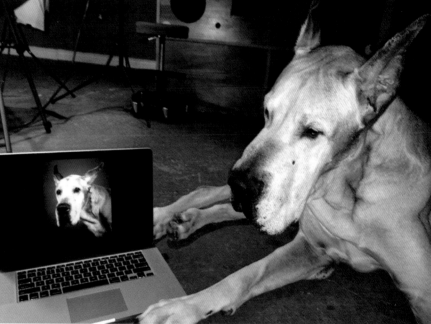

PETE THORNE is a professional photographer. He is a graduate of the Nova Scotia College of Art and Design, and lives in Toronto.

www.petethornephoto.com
https://www.facebook.com/oldfaithfulphoto
Twitter: @a_pete_tweet
Instagram:Old_Faithful_Photo